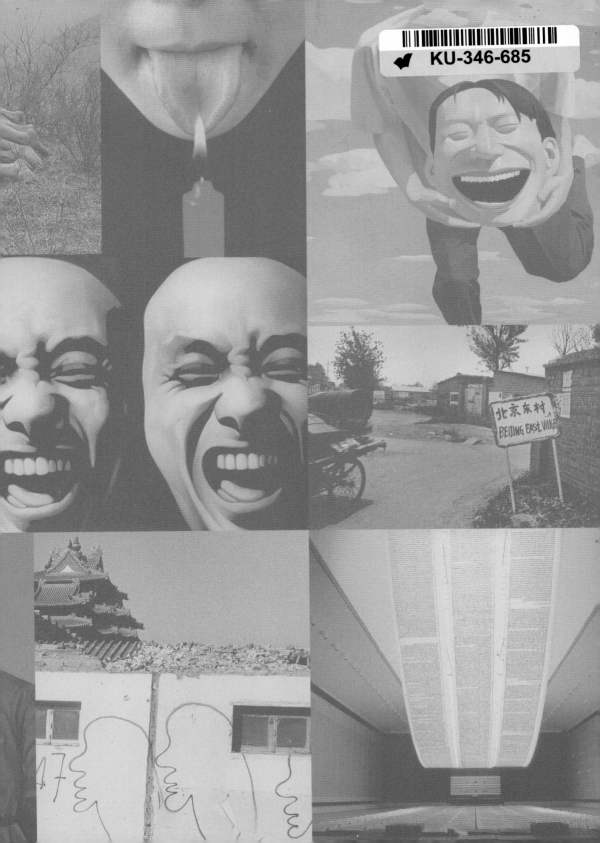

# Chinese Contemporary Art
# 7 things
# you should know

By Melissa Chiu

# Contents

# Introduction

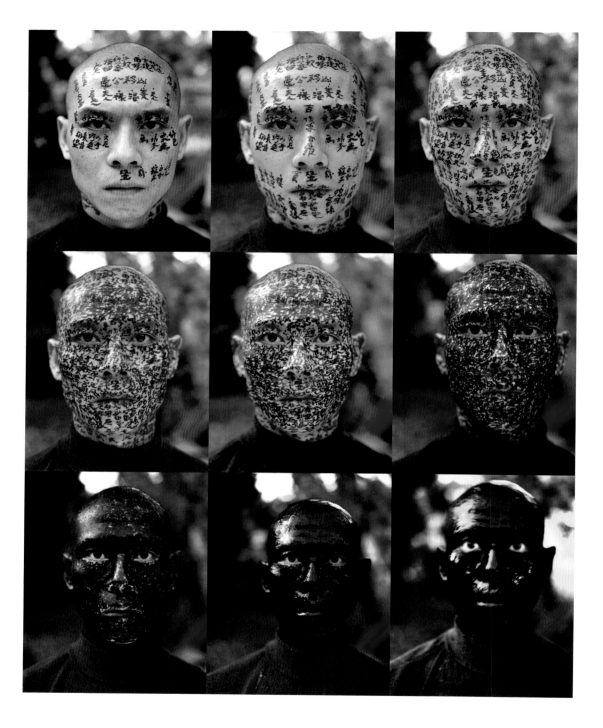

**S**ometimes it seems that scarcely a week goes by without a newspaper or magazine article on the Chinese contemporary art scene. Record-breaking auction prices make good headlines, but they also confer a value on the artworks that few of their makers would have dreamed possible when those works were originally created—sometimes only a few years ago, in other cases a few decades. It is easy to understand the artists' surprise at their flourishing market and media success: the secondary auction market for Chinese contemporary art emerged only recently, in 2005, when for the first time Christie's held a designated Asian Contemporary Art sale in its annual Asian art auctions in Hong Kong. The auctions were a success, including the modern and contemporary sales, which brought in $18 million of the $90 million total; auction benchmarks were set for contemporary artists Zhang Huan, Yan Pei-Ming, Yue Minjun, and many others. The following year, Sotheby's held its first dedicated Asian Contemporary sale in New York. It grossed $13 million and established new records for several artists. In the following years, Chinese contemporary art attracted enough interest to prompt its own dedicated sales in New York, London, Hong Kong, and even Beijing, where a domestic market for contemporary art has also begun to emerge.

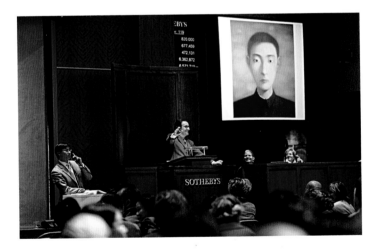

▲ Sotheby's auctioneer Benjamin Doller selling a record-breaking Zhang Xiaogang on March 31, 2006
Courtesy of Sotheby's

◀ **Zhang Huan** | *Family Tree* 2000 Nine color photographs 55 × 41 cm each Courtesy of the artist

■ (Page 8) **Geng Jianyi** | *The Second Situation* 1999 Oil on canvas 150 × 200 cm Courtesy of Private Collection

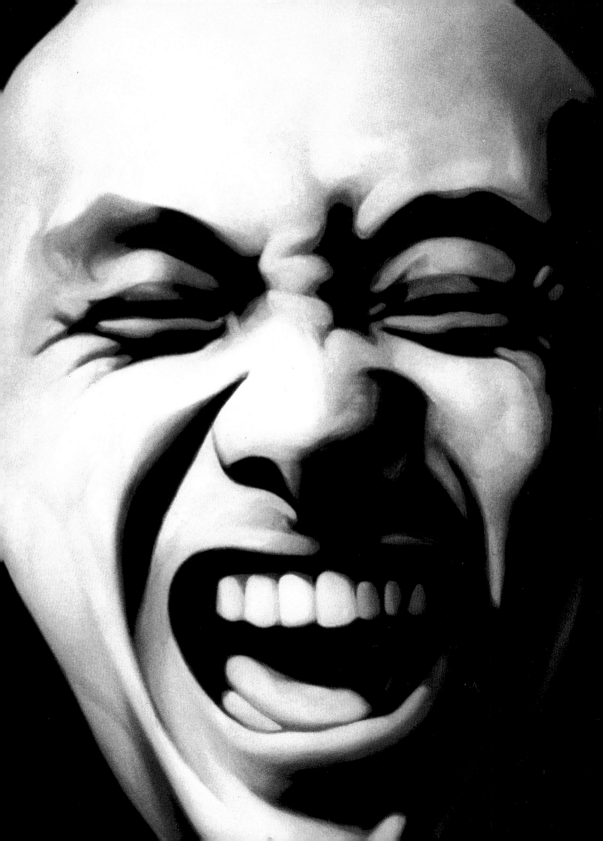

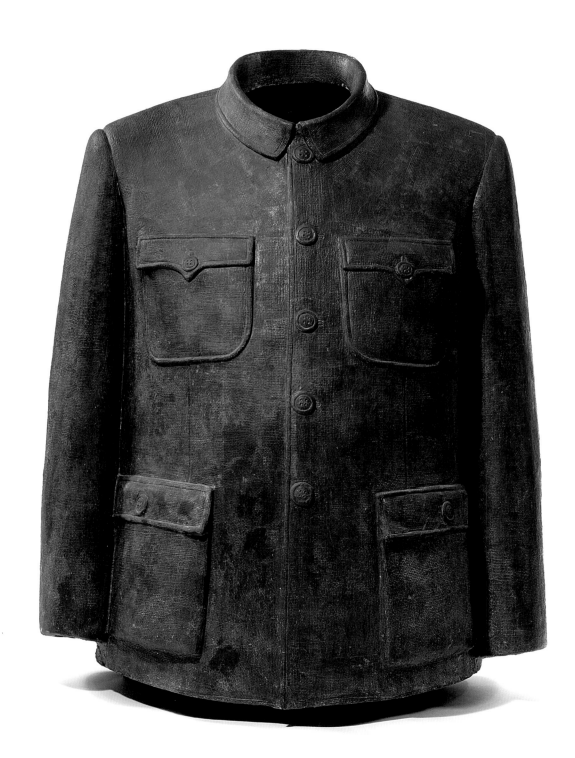

Auction house sales are crucial, but don't tell the entire story. They are a midpoint along the art-market continuum, which begins something like this: Artists make the work, which they often sell in the first instance through galleries. The work is acquired by private collectors, sometimes changing hands multiple times in the secondary auction market. The best works frequently end up in museum collections, where they are preserved for posterity.

But the unique environment in 1990s China created a refraction of this continuum. Through much of the decade, there was no local gallery system in place in China; as a result, artists became savvy at marketing and selling their work themselves, in addition to being represented by galleries around the world. More recently, with the growth of the auction market for Chinese contemporary art, artists have actively put their work up for sale—something that Western artists rarely do.

In the West, museums may be seen as the end point of the art market. But when it comes to Chinese contemporary art, they were also a starting point. As early as 1993, major survey exhibitions of avant-garde Chinese art were shown in museums in Hong Kong, Berlin, and Sydney, and later in New York, San Francisco, and Chicago. These museum touring exhibitions gave enormous exposure to Chinese artists and laid the groundwork in the West for a later appreciation of Chinese contemporary art in its historical context.

In China today, contemporary art is readily available in public museums and private galleries in burgeoning gallery districts, and in three new art fairs in Beijing and Shanghai. Abroad, Chinese artists are the subject of museum retrospective exhibitions and grace the covers of international art magazines. Chinese contemporary art has come of age; yet there are few reference books for the reader who wants a quick but precise history of the field. This book aims to fill that gap. Short and to the point, it is arranged into seven sections outlining the rudiments of Chinese contemporary art: what you need to know about the artists, the art market, and what can legitimately be called a new art movement, perhaps the first great art movement of the 21st century. This book is not a guide on how to buy and sell artworks, but it does contain information essential to anyone interested in learning more about the art in this thriving new arena.

◀ **Sui Jianguo** | *Legacy Mantle* 1999 Painted fiberglass 41 × 33 × 20 cm Courtesy of the artist

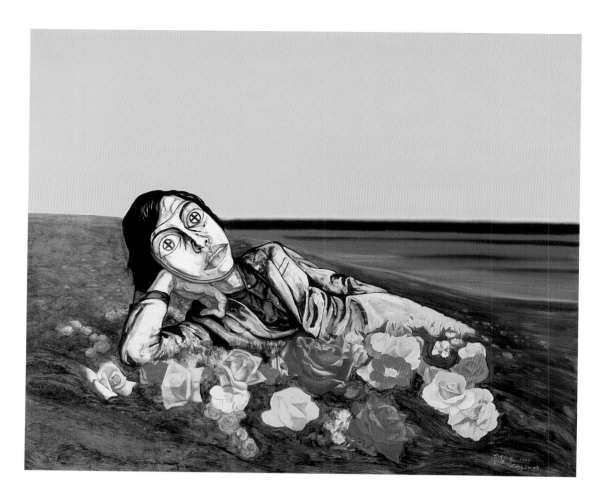

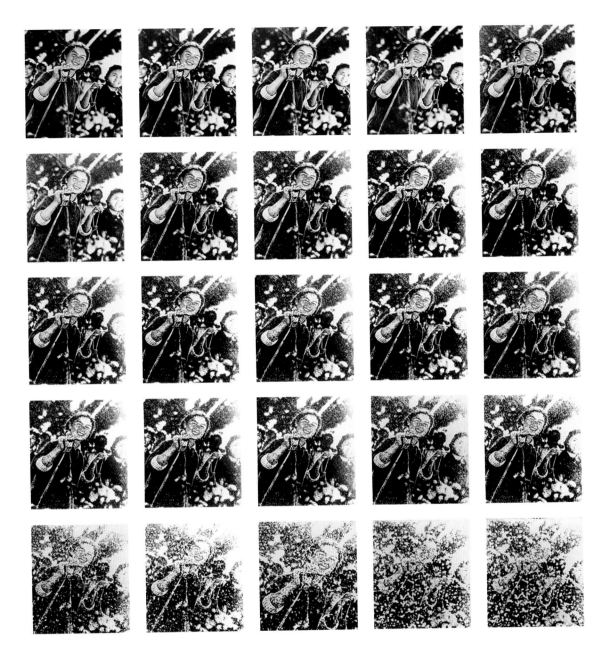

▲　**Zhang Peili** │ *Continuous Reproduction* 1993 Black and white photographs 30 × 25 cm each
Courtesy of Private Collection
◄　**Zeng Fanzhi** │ *Untitled (reclining figure)* 1998 Oil on canvas 152 × 203 cm Courtesy of Private Collection

# 1.

Contemporary art in China
began decades ago.

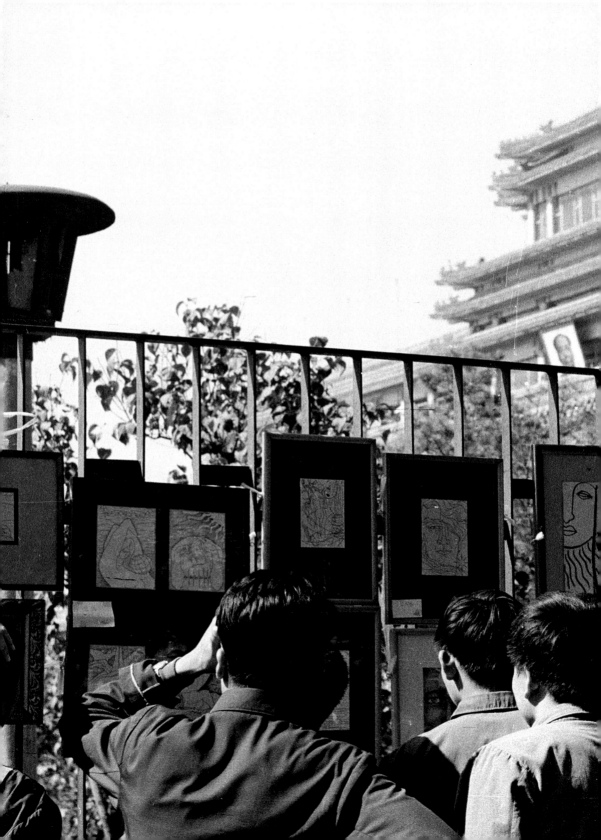

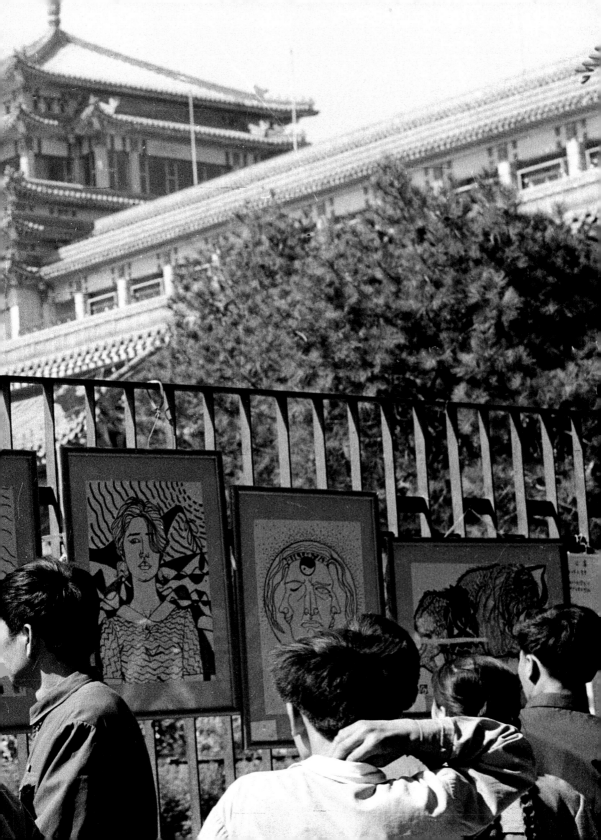

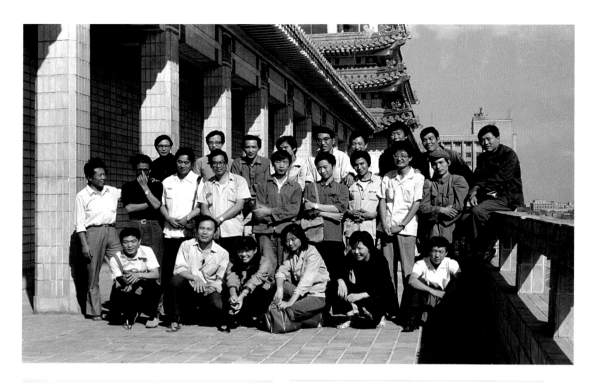

《星星》 露天美展

作品有油画、国画、

钢笔画、木刻、木雕等一百五十余幅（件）

时 间：9 月 27 日至 10 月 8 日

地 点：美术馆东侧花园

〈Stars〉Open Air Art Exhibition

Works include oil painting, Chinese painting,

ink drawing, woodblock prints, wooden sculpture (150 artworks)

Time: September 27 - October 8

Location: Garden east of the National Art Gallery

Contemporary art in China began decades ago.

*T*he history of Chinese contemporary art dates back to 1979. This is sometimes difficult for people outside China to understand or appreciate, for as I mentioned above, the international secondary market for Chinese art was established only a few years ago—and with no secondary market, many dealers and collectors assumed that no artwork had been produced before that time.

The beginning of Chinese contemporary art more or less coincides with former Chinese leader and economic reformist Deng Xiaoping's declaration of his Open Door policy, which ushered in an era of economic and cultural liberalization. Though Deng probably never considered the impact of the policy on the visual arts, as a result of his reforms, artists, for the first time, had much greater access to information about foreign art movements and styles. Suddenly, they could read Western art magazines and books, which most often came into the country through Hong Kong. They devoured information about Dada and Surrealism. Robert Rauschenberg's 1985 exhibition at the National Art Gallery in Beijing (now the National Art Museum) was also influential on this generation of artists. Known as the '85 New Wave, this early group frenetically experimented with art forms and styles ranging from Post-Impressionist-inspired painting to Dada-influenced performance art. Across the country, artists explored their newfound creative freedom. Many banded together to form collectives, movements, and groups to promote their work. Among them were New Figurative, later renamed Southwest Art Group, in Kunming (1985-87); Xiamen Dada in Xiamen (1985); the Hangzhou Youth Creativity Society, later renamed the Pond Group, in Hangzhou (1985); and the New Analysts Group in Beijing (1988-95). Notable artists involved in these groups include Wang Youshen, Wang Du, Lin Yilin, Huang Yong Ping, and Wu Shanzhuan.

The Stars, one of the earliest groups to reflect this new era, preceded the '85 New Wave. Formed in Beijing in 1979, it was a loose-knit collective of self-taught artists. That year, The Stars staged an exhibition of their work in a park just outside the National Art Gallery. Though China had liberalized the laws concerning access to information, the

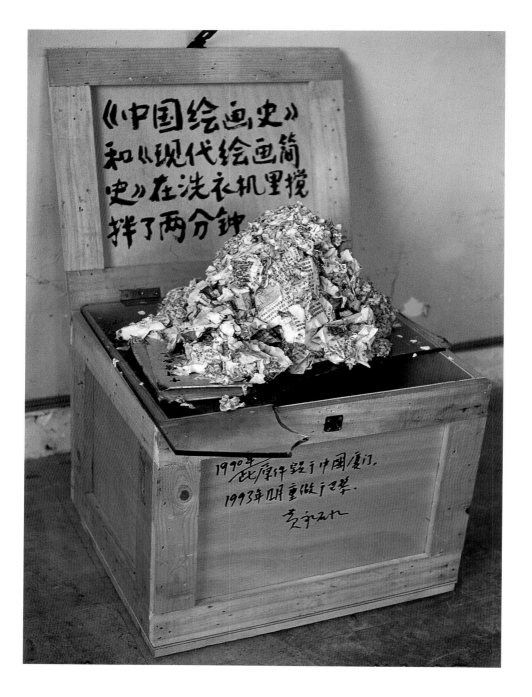

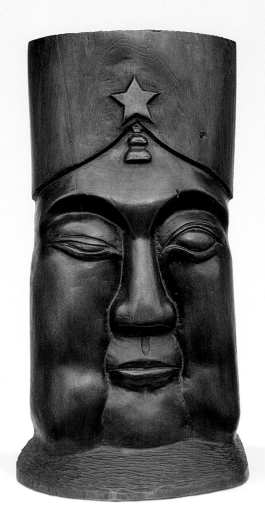

▲ **Wang Keping** | *Idol* 1979  Wood  Courtesy of the artist and 10 Chancery Lane Gallery, Hong Kong

◀ **Huang Yong Ping** | *"The History of Chinese Painting" and "The History of Modern Western Art"*
*Washed in a Washing Machine for Two Minutes* 1987  Installation, paper pulp, wood, glass  Dimensions variable
Courtesy of the artist and Barbara Gladstone Gallery, New York

■ ( **Page 22** ) Artworks by the Xiamen Dada group being burned after their first exhibition, Hangzhou, 1986
Courtesy of the Office for Discourse Engineering, Beijing

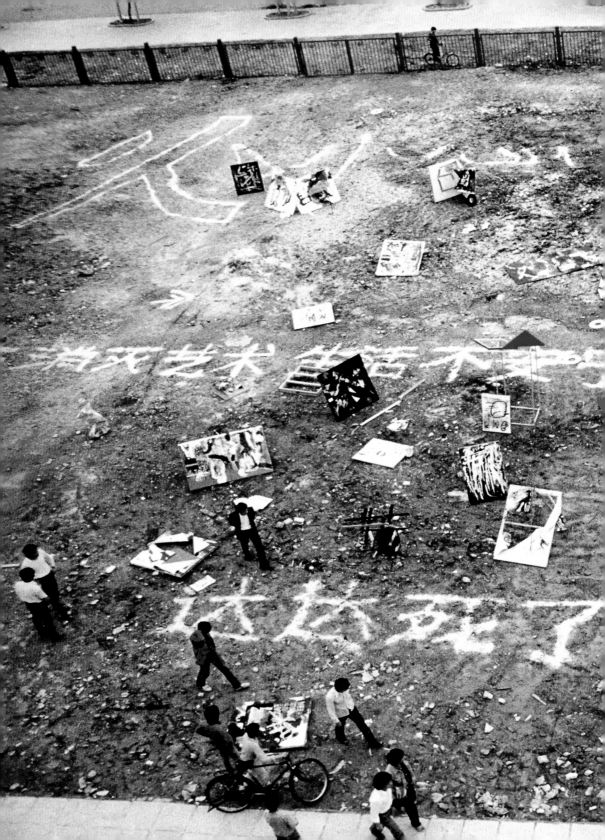

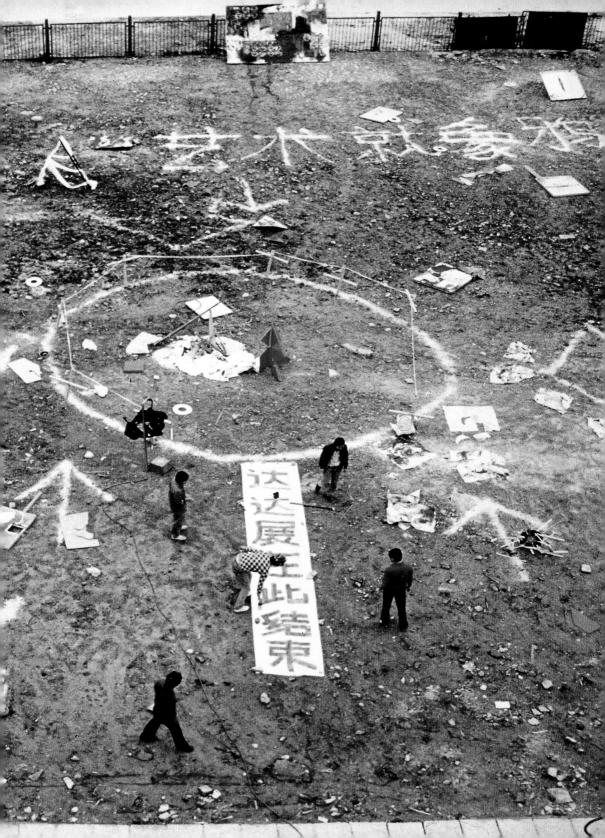

display of art in government museums was still tightly controlled. Knowing that their work was unlikely to win official sanction, The Stars chose to present it illegally, in a public space where it would gain the widest exposure. When the show was forcibly dismantled by the police, the artists initiated a public protest. Throughout the past two decades a similar pattern has occurred again and again, as artists tested the limits of state tolerance.

Perhaps the most high-profile episode of government censorship concerned the *China Avant-Garde* exhibition presented at the National Art Museum in Beijing in February 1989. The show was shut down twice by the government authorities, first for unsanctioned happenings and performance art at the opening preview, and again following a bomb threat the next week. In all, the exhibition was open for only nine days of its scheduled fifteen-day run.

The drama of the show's initial closure heralded a period of increasing repression in China, culminating in the crackdown on June 4, 1989, in which the country's political leadership used military tanks and troops to disperse pro-democracy demonstrators in Tiananmen Square. The protestors, including artists and art students, showed great bravery in defying the nation's political leaders and became heroes to many in China and abroad. Following the Tiananmen Square incident, the government blocked access to Western publications and information, and pressured art schools and museums to prevent artists from showing their work in public spaces.

Of course, Chinese contemporary art didn't end entirely. Throughout the early 1990s, artists continued to make what you might call experimental contemporary art, but they had to be more resourceful in finding ways to show it. Many gave up on the public museum system entirely and showed their work in the unofficial, private spaces of their studios and homes. Dubbed "apartment art," these small-scale shows of performance and installation works were similar to the under-the-radar activities that artists in Communist Russia had engaged in during the 1980s. In Beijing, some artists took the unprecedented step of opting out of Chinese society, with its rigid system of communal work units. They settled on the outskirts of the city, where they created an artists' community known as the East Village—an homage to the New York City neighborhood that in the 1980s was home to a thriving contemporary art community. In Beijing's East Village, artists Zhang Huan,

▶  Rong Rong | *Rong Rong's East Village* 1993-1998 Black and white photograph 50 × 40 cm Courtesy of the artist
■  (Page 26) Fang Lijun | *Series II, No. 06* 1991-1992 Oil on canvas 200 × 200 cm Courtesy of Private Collection

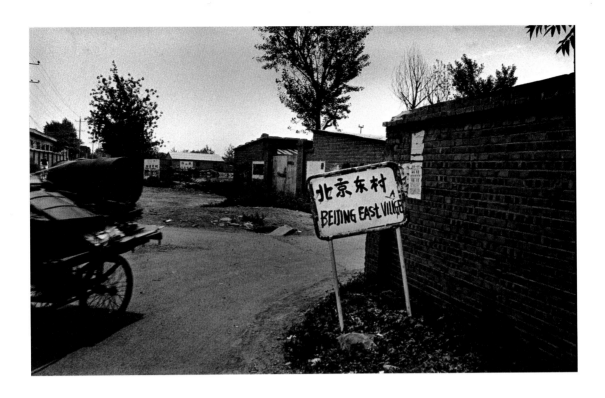

Ma Liuming, Cang Xin, Zhu Ming, Xing Danwen and Rong Rong formed the core group, creating photographs, installations and performances in their meager, bare-bones studios, where they lived alongside farmers and itinerant workers.

Some artists forged connections with critics and curators outside China, who organized the first international exhibitions of Chinese contemporary art in places like Hong Kong and Berlin. These exhibitions did not ignite the art market but gave the nascent Chinese art community an important morale boost. In time, through wider awareness of the quality and depth of the art, these early shows gave rise to many more, and finally to the international recognition of Chinese artists.

During this period, Political Pop and Cynical Realism were the two art styles that attracted the greatest attention outside China—perhaps because they seem to capture, in a fundamental way, the growing pains of China's transition from a Communist society to a market-driven one. Political Pop may be best described as a movement rather than a style, since the artists associated with it used a range of visual approaches. Emerging with the centennial celebration of Mao's birth in 1993, Political Pop paintings

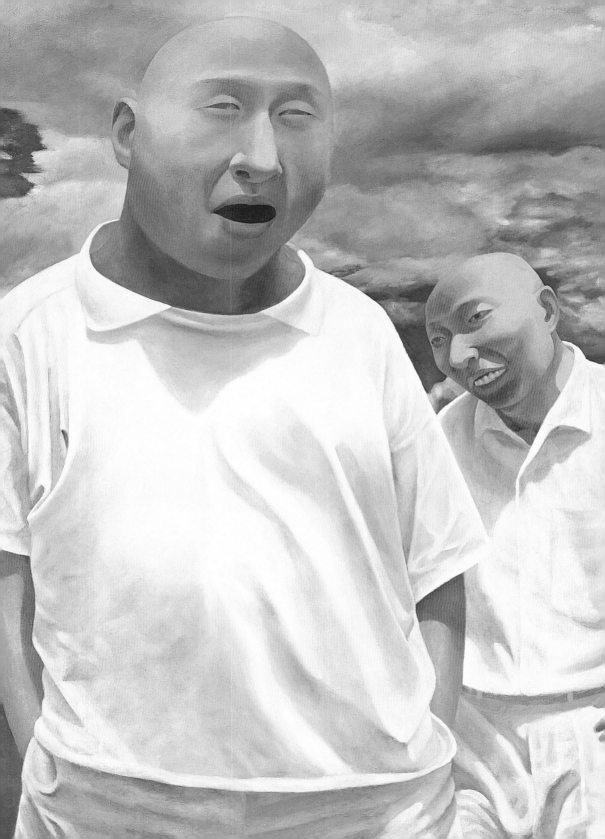

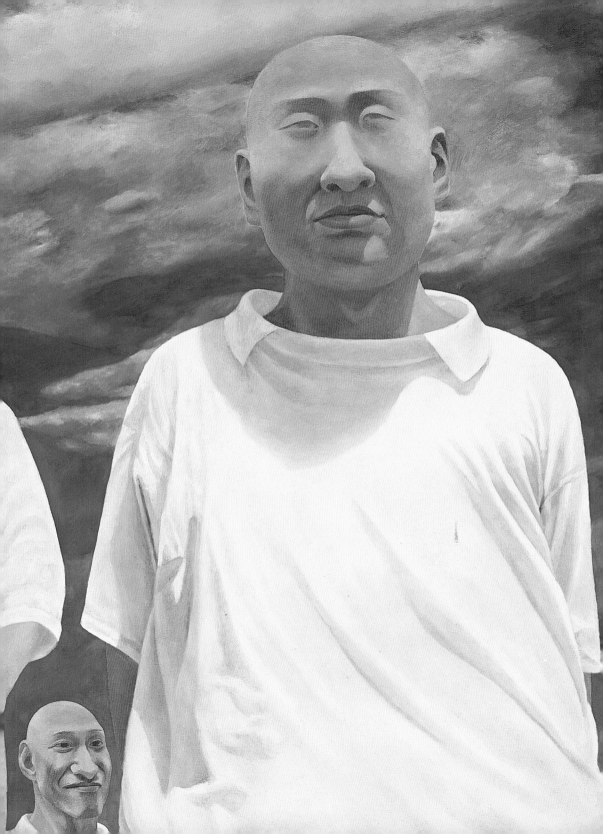

portray the leader, often in an irreverent way. Li Shan's paintings, for instance, depict him with a lotus flower sprouting from his mouth; Zhang Xiaogang's family portraits evoke his specter through the small Mao badges worn by all the figures depicted, placing these portraits in the era of the Cultural Revolution. Cynical Realism is similar to Political Pop in tone and temperament, but rather than Mao, the focus is on the individual. In portraits and self-portraits, artists and others are shown as anxious figures, grimacing as if putting on a brave face for the outside world, or in the case of Yue Minjun, perpetually laughing in response to China's upheavals. In addition to Yue, notable Cynical Realist artists include Fang Lijun and Geng Jianyi.

Other movements followed, such as Gaudy Art, which references popular culture and consumerism in colorful, over-the-top ceramic and resin sculptures by the Luo Brothers, Xu Yihui, and other artists. In the mid- to late 1990s, conceptual art and installation art came to dominate contemporary art production in China. Some of the leading exponents of these forms were Gu Dexin, Wang Jianwei, Lin Tianmiao, Shi Yong, Wang GongXin, Sui Jianguo, and Zhang Peili. In many instances, their work had evolved from figurative painting in the late 1980s to ambitious installations or sculptures in the 1990s. On a certain level, they sought

to define themselves as experimental through their choice of media, in contrast to the more traditional forms, like ink painting, advocated by their peers in official art circles.

In the late 1990s, video and photographic equipment became more accessible to artists. As a result, image processing labs began to open as well. This spurred a new shift, as artists started to experiment in greater numbers with large-scale prints, computer-generated imagery, and video installations. For artists such as Feng Mengbo, Zhang Peili, Hai Bo, and Wang Jianwei, the technology opened up additional possibilities for the juxtaposition of old film footage and photographs from their youth during the Cultural Revolution. For a younger generation, it offered new ways to capture the changing, increasingly cosmopolitan environs of Chinese urban centers—for example, Miao Xiaochun's photographs of crowds enjoying leisure activities in zoos and shopping malls, or Yang Fudong's photographs and videos, which depict the newly emergent class of office workers in Shanghai.

▲   Hai Bo | *Three Sisters* (diptych) 2000  Black and white photographs  89 × 61 cm each  Courtesy of the artist

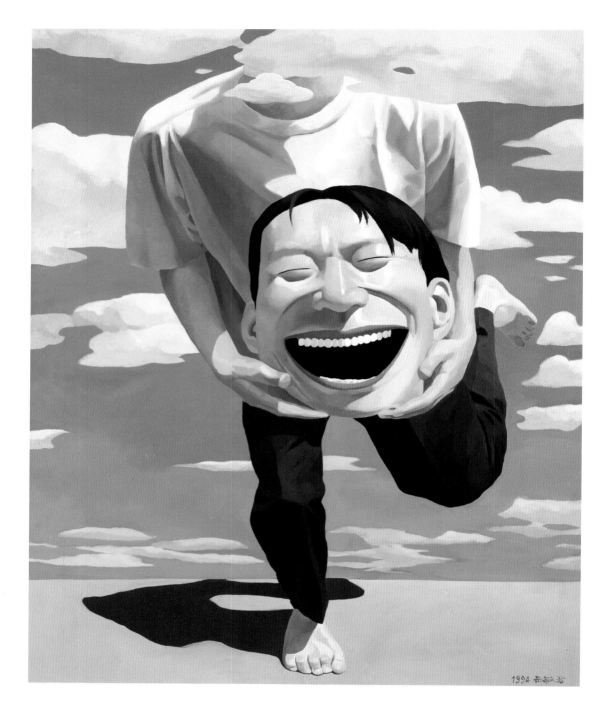

Contemporary art in China began decades ago.

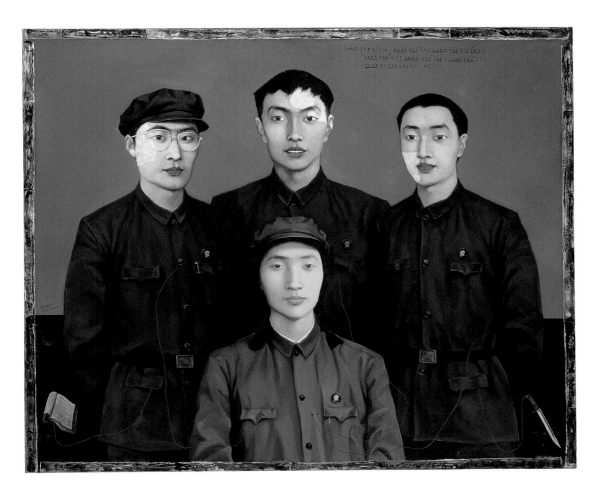

▲ **Zhang Xiaogang** | *Bloodline Series: Mother with Three Sons (The Family Portrait)* 1993
Oil on canvas 149 × 180 cm Courtesy of the artist

◀ **Yue Minjun** | *Untitled (Laughing Head)* 1994 Oil on canvas 66.5 × 80.5 cm Courtesy of Private Collection

▲ Xu Bing | *Book from the Sky* 1987-1991 Hand printed books, ceiling and wall scrolls printed from
  wood letterpress type using false Chinese characters Dimensions variable
  installation view in *Three Installations by Xu Bing*, Elvehjem Museum of Art, Madison, Wisconsin (1991)
  Courtesy of Xu Bing Studio

▶ Liu Wei | *Untitled* 1998 Oil on canvas 200 × 120 cm Courtesy of the Sigg Collection

**2.**

Chinese contemporary art
is more diverse
than you might think.

**P**olitical Pop and Cynical Realism remain the best known contemporary Chinese art styles in the West. Leading exponents of Political Pop include Yu Youhan and Wang Guangyi; additional Cynical Realist artists include Liu Wei, Zhang Xiaogang, and Zeng Fanzhi. Equally well known are painters whose works don't conform to a particular movement or style, such as Chen Danqing, Liu Xiaodong, Yang Shaobin, and Yu Hong.

▲ **Yang Shaobin** | *Untitled* 1995 Oil on canvas 120 × 120 cm Courtesy of Private Collection

▶ **Wang Guangyi** | *Great Castigation Series: Coca-Cola* 1993 Oil on canvas 200 × 200 cm Courtesy of Private Collection

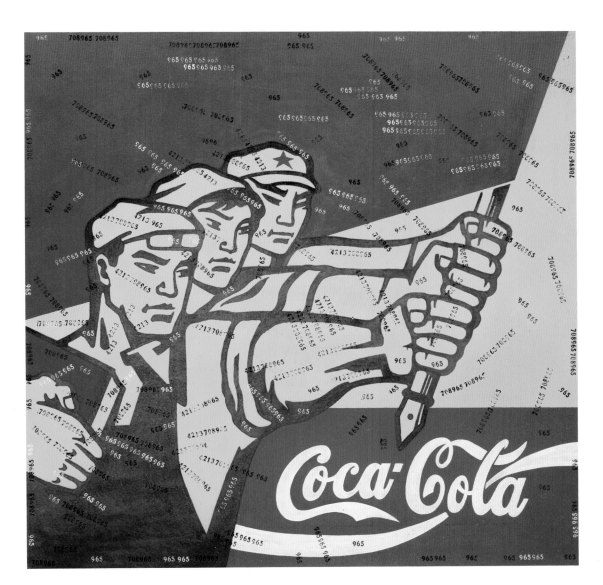

They, too, have become market darlings, achieving record prices at auction and attaining remarkable wealth and rock-star-like celebrity in China.

But these internationally acclaimed elite are not the only influential voices among the generation to emerge since the mid-1990s. Younger artists such as Wang Qingsong, Yan Lei, Song Tao, Xu Zhen, and Qiu Anxiong are not as concerned with the issues that occupied their immediate predecessors, such as the Cultural Revolution or personal self-analysis (the main themes of Political Pop and Cynical Realism). Nor are they primarily interested in painting as a medium. Today, performance and installation are the mainstays of experimental art in China; photography and new media are increasingly popular. Cui Xiuwen, for instance, has won attention for a revealing video shot with a camera hidden inside a women's bathroom in a Beijing nightclub. Cao Fei creates art from Second Life, a virtual-reality computer program in which users create online versions of themselves, or avatars, which interact with the avatars of other users. Nor is such

▲  Cao Fei | *A Mirage (COSPlayers Series)* 2004 Digital C-print 74.3 × 99.7 cm
   Courtesy of Lombard-Freid Projects, New York

▶  **Zhou Chunya** | *Untitled (Green Dog)* 1999 Oil on canvas 120 × 150 cm Courtesy of Private Collection

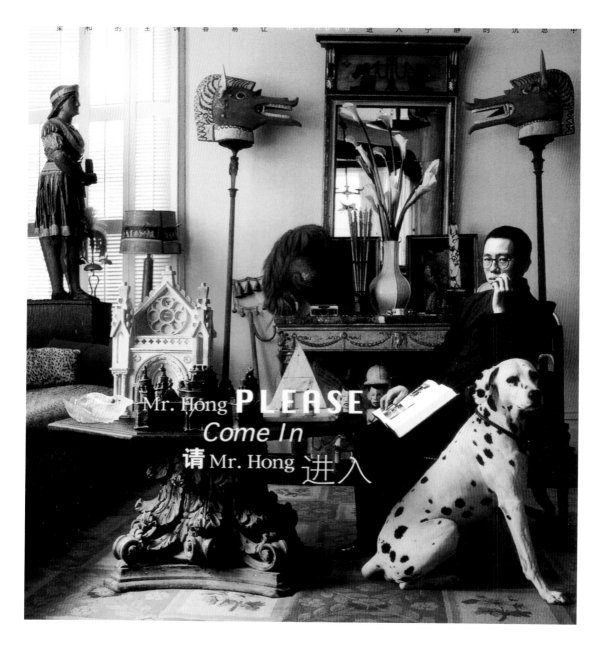

Mr. Hong PLEASE Come In
请 Mr. Hong 进入

Chinese contemporary art is more diverse than you might think.

experimentation beyond the contemporary art market. Cao Fei's Second Life virtual space, featuring her virtual reality avatar, China Tracy, is available for a two-year lease.

There is such diversity in current Chinese art that it is far more challenging to identify key trends and movements than it was twenty years ago, when there were fewer artists and the Chinese contemporary art world was centered, for the most part, in Beijing. Today, there are active, fully developed art scenes in several cities, including Shanghai, Guangzhou, Chengdu, and Nanjing—all of which now host international art biennales or triennials. Insofar as one can generalize about current Chinese art, we can say that the artists look more to the future than to the past, to present-day realities and opportunities rather than to history and its lessons.

▲  Yang Fudong | *Seven Intellectuals in Bamboo Forest* 2003 Video Courtesy of Asia Society Museum, New York
◀  Hong Hao | *Mr. Hong Please Come In* 1998 Color photograph 146 × 127 cm Courtesy of the artist

▲ Wang Jinsong | *City Wall* (detail) 2002 Color photograph 127 × 91 cm Courtesy of the artist

# 3.

Museums and galleries
have promoted
Chinese contemporary art
since the 1990s.

Museums took the lead in promoting Chinese contemporary art to audiences outside China. The first wave of exhibitions, which occurred in 1993, included *China's New Art, Post-1989* at the Hong Kong Arts Centre; *Mao Goes Pop: China Post 1989* at Sydney's Museum of Contemporary Art; and *China Avant-Garde: Countercurrents in art and culture* at Haus der Kulturen der Welt in Berlin. Important shows later in the decade include *Another Long March: Chinese Conceptual and Installation Art in the Nineties* (1996) in Breda, the Netherlands; *Inside Out: New Chinese Art* (1998) in New York and San Francisco; and *Transience: Chinese Experimental Art at the End of the Twentieth Century* (1999) in Chicago. In some cities, galleries staged smaller shows of Chinese contemporary art in advance of museum exhibitions. New York, for instance, got its first taste of Chinese contemporary art in the mid-1990s with exhibitions of Chen Zhen at Deitch Projects; Huang Yong Ping at Jack Tilton; Feng Mengbo at Holly Solomon; and group exhibitions at Max Protetch, Jack Tilton, and Lehmann Maupin.

Despite growing international interest in Chinese contemporary art, at this point there was still no real gallery system in China itself. The handful of galleries that did operate endured not only a lack of critical and market interest but hostility from the Chinese government and its official art system, which remained in place through the late 1990s. In this environment, commercial galleries took responsibility for documenting and promoting the work of experimental artists. They often assisted foreign curators in research and planning for the early international exhibitions. Among the two earliest galleries in China were Red Gate Gallery in Beijing and ShanghART in Shanghai. Run by foreigners, they were both originally housed in luxury hotels, where they had ready access to foreign clientele and a certain degree of security from Chinese authorities, who may have assumed that what foreigners bought was beyond their concern. Both of these important early galleries are still in operation. In the early days, Hanart T Z Gallery and Schoeni Gallery, both in Hong Kong, also played a pivotal role in the circulation and sale of works. Hanart's owner, Johnson Chang, also served as curator for some of the important exhibitions of that era.

▶ Cover of *Inside Out: New Chinese Art* exhibition catalogue  1998

Museums and galleries have promoted Chinese contemporary art since the 1990s.

Inside Out

# New Chinese Art

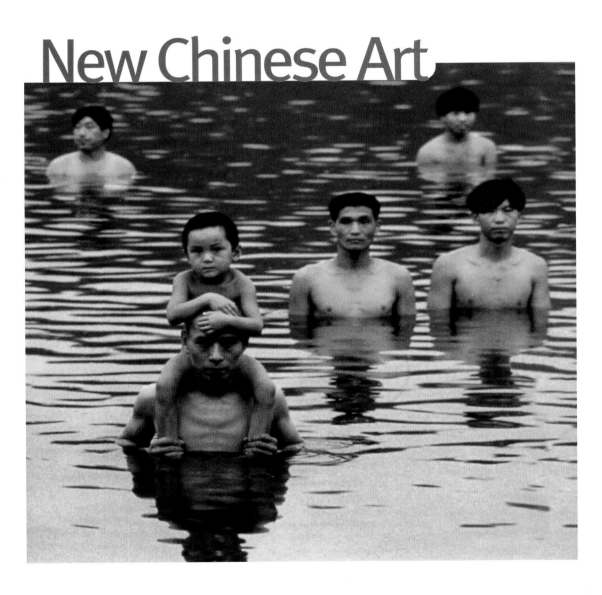

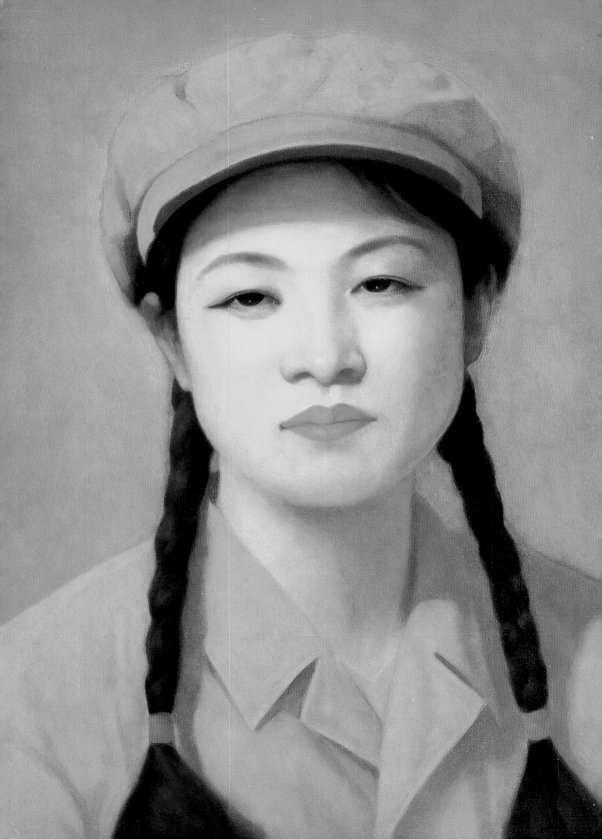

These days, China has a thriving gallery scene, with gallery districts in major cities. One of the largest in Beijing is 798, located in the northeast of the city and named for the former factory complex where many of its galleries are located. There are also clusters of galleries in other areas of Beijing, such as Caochangdi East End and Jiuchang Art Districts, and in Shanghai (Mo Gan Shan Lu); and in regional cities like Chongqing (Tank Loft). Foreign galleries and dealers have also begun moving into these districts, setting up their own galleries or going into partnership with local dealers and investors. Among them are the New York-based Chinese Contemporary Gallery; Italian-based Galleria Continua; and the Japanese-owned Beijing Tokyo Art Projects, all of which have galleries in the 798 complex. The Korean-owned Gallery Hyundai and Arario Gallery have established spaces in Beijing. New York's Jack Tilton Gallery sponsors a residency space in Tongxian County, roughly an hour's drive north of central Beijing. Galleries run by Chinese dealers sell to a growing number of local collectors as well as foreigners; among the most prominent are Xin Dong Cheng in Beijing and the Shanghai Gallery of Art in Shanghai.

▲  Tank Loft Contemporary Art Center, Chongqing, China
◄  **Qi Zhilong** | *Untitled* 1999 Oil on canvas 80 × 50 cm Courtesy of the Sigg Collection
■  ( Page 50 ) **Cai Guo-Qiang** | *Light Cycle, Explosion Project for Central Park* 2003 Central Park, New York Courtesy of the artist

# 4.

Government censorship
has been an influence
on Chinese artists,
and sometimes still is.

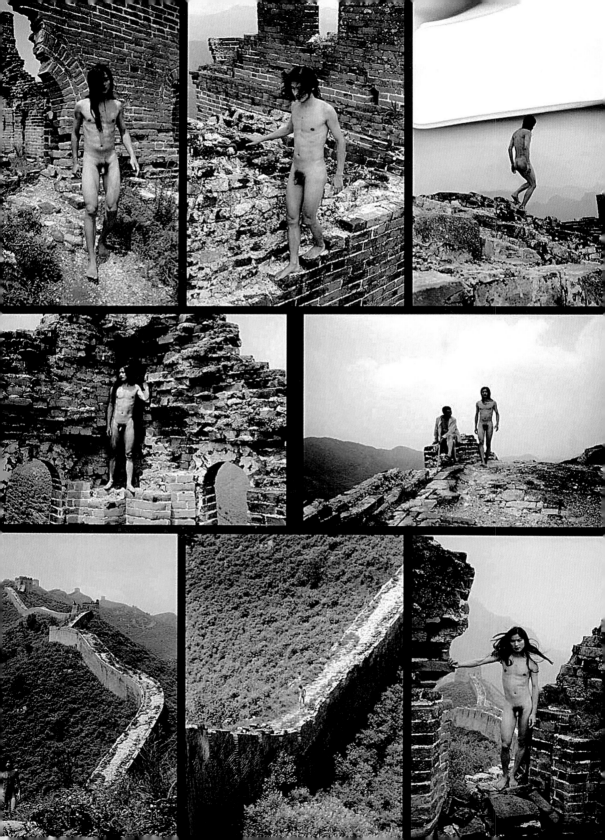

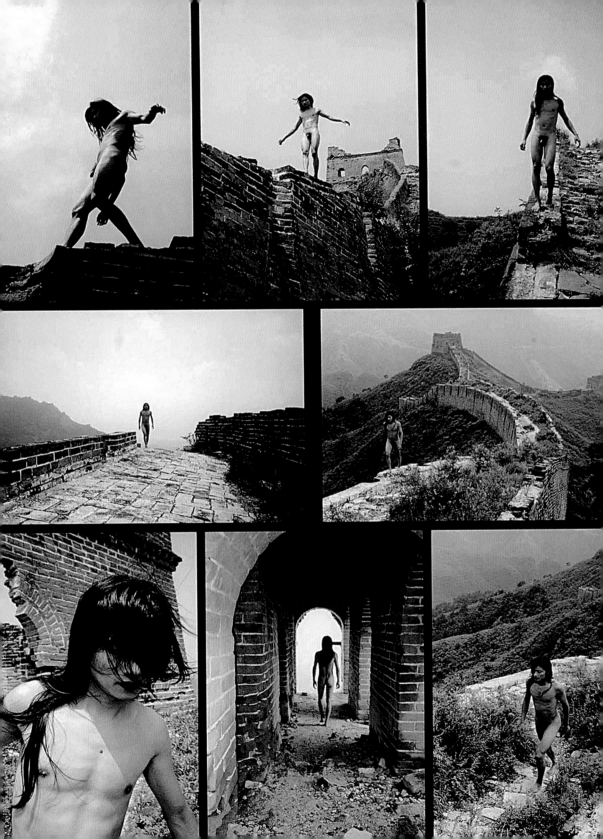

*T*hough China is a one-party state with a highly centralized political structure, it would be inaccurate to say that the official party attitude toward culture is uniformly repressive or monolithic. Over the past two decades, attitudes toward contemporary art in China have had as much to do with the country's volatile sociopolitical situation as with official concern over the art itself. The June 4, 1989 Tiananmen Square incident prompted a nationwide crackdown on Chinese media, educational, and cultural institutions. The fact that experimental art had found support in official circles—in state-run art schools, museums, and art magazines—during the late 1980s is an indication

■  ( Page 54 ) **Ma Liuming** | *Fen-Ma Liuming Walks on the Great Wall* 1998 Chromogenic print 127 × 199 cm
   Courtesy of the artist
▲  **Zhang Huan** | *To Add One Meter to an Anonymous Mountain* 1995 Black and white photograph 104 × 154 cm
   Courtesy of the artist
▶  **Lin Yilin** | *Safely Crossing Linhe Street* 1995 Video Courtesy of Asia Society Museum, New York

**56**  Government censorship has been an influence on Chinese artists, and sometimes still is.

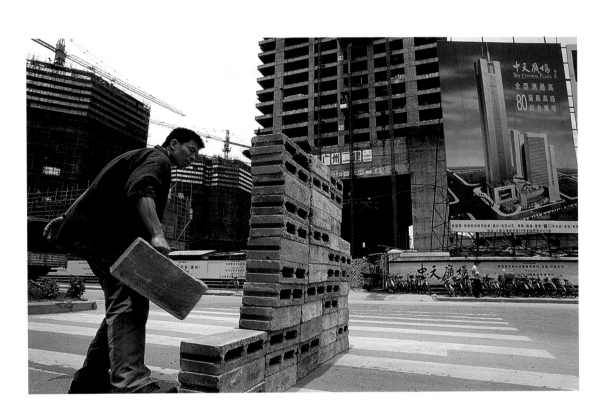

of how liberal the art world in China had become. After Tiananmen Square, those who had championed Western-style experimental art were marginalized or forced out of their positions. The work of artists once deemed acceptable was now seen as a sign of excessive liberalization—having led, in the minds of the Chinese political authorities, to attempts to challenge the supremacy of the ruling party. Studio shows and private displays of experimental art also came under scrutiny. The stakes were high; if their work attracted police attention, artists were often arrested and jailed. Performance art was especially risky. One pioneering artist, Ma Liuming, was arrested when scandalized neighbors reported a performance in which he appeared naked—a profound social taboo.

As the 1990s progressed, there were countless examples of government censorship in the visual arts. Contemporary art exhibitions were routinely closed by the authorities because they lacked official permission or the subject matter was deemed subversive. Artists gradually came to understand the unwritten conditions that governed the new, more paranoid political environment: as long as their work did not include or refer to nudity, sex, violence, or politics, they would be left alone. But some artists, like Wang Jin, Yan Lei, and the Big Tail Elephant Group (Liang Juhui, Xu Tan, Lin Yilin, and Chen Shaoxiong) in Guangzhou, refused to bend, staging brief exhibitions—some lasting a few days or even a few hours—in private homes and studios, or in the public sphere on busy streets or construction sites. Their work continued to deal with these forbidden themes, but often in a deliberately ambiguous or obfuscatory way. Little art from this period has survived, but these under-the-radar exhibits were often less about the work than the fact of its presentation. Given the repressive conditions under which they were staged, the events could be understood as experimental artworks in and of themselves.

Publishing was another way that artists got the word out about their activities during this time. Edited by Ai Weiwei, Xu Bing, and Zeng Xiaojun with managing editor Feng Boyi, *Black Cover Book* focused on early 1990s experimental art. *Chinese Contemporary Artists Agenda*, compiled in 1994 by artists Wang Luyan, Wang Youshen, Chen Shaoping, and Wang Jianwei, featured hypothetical drawings of installations by close to twenty artists across China.

▶  **Ai Weiwei | *Dropping a Han Dynasty Urn*** 1995  Three black and white photographs  127 × 100 cm
Courtesy of the artist

Government censorship has been an influence on Chinese artists, and sometimes still is.

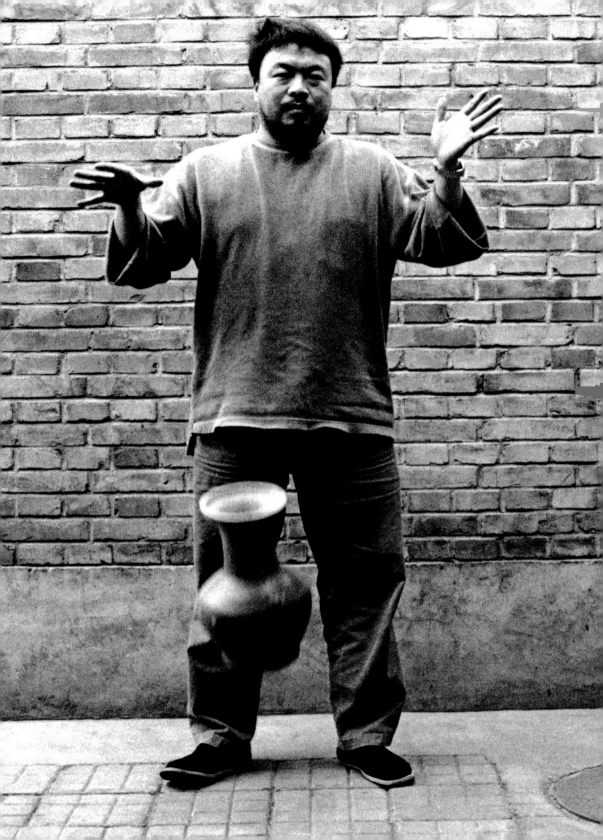

As Chinese society has become more affluent and more open, incidents of government censorship occur far less often. Experimental contemporary art can be seen in museums around the country, including the National Art Museum in Beijing, the Shanghai Art Museum in Shanghai, and the Guangdong Museum of Art in Guangzhou. But artists still know, in the back of their minds, that their work is subject to official scrutiny, and that they can easily run afoul of the police if they breach the three Nos: no politics, no violence, no nudity. This fact was brought home to me at the first Shanghai art fair in 2007. The museum where I work had been invited to take an institutional booth at the fair. Just as we were finalizing our proposal, we received word that all artworks had to be pre-approved by the Chinese authorities. Such a request would be intolerable elsewhere.

▶  Qiu Zhijie | *Tattoo Series #3* 1994 Color photograph 100 × 80 cm Courtesy of Private Collection
■  ( Page 62 ) **Zhang Dali** | *Demolition: Forbidden City, Beijing* 1998 Color photograph 100 × 150 cm Courtesy of the artist

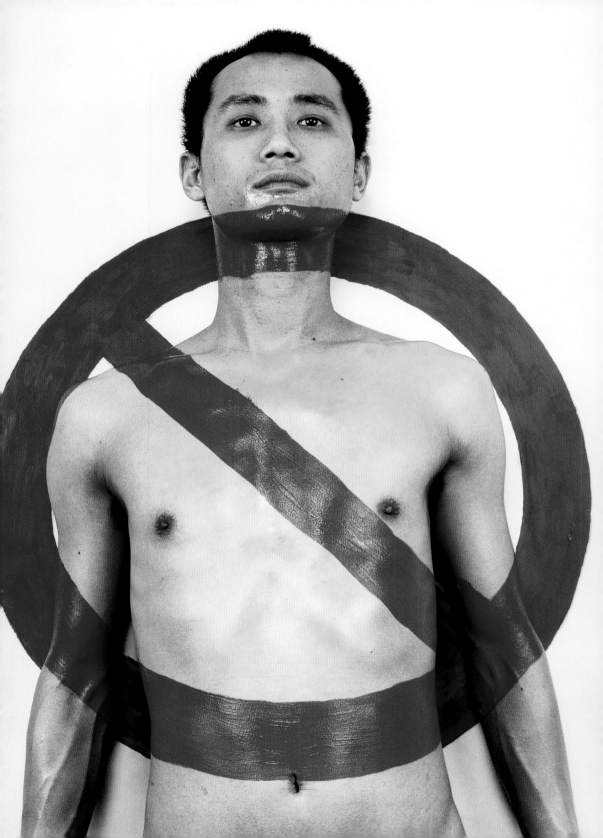

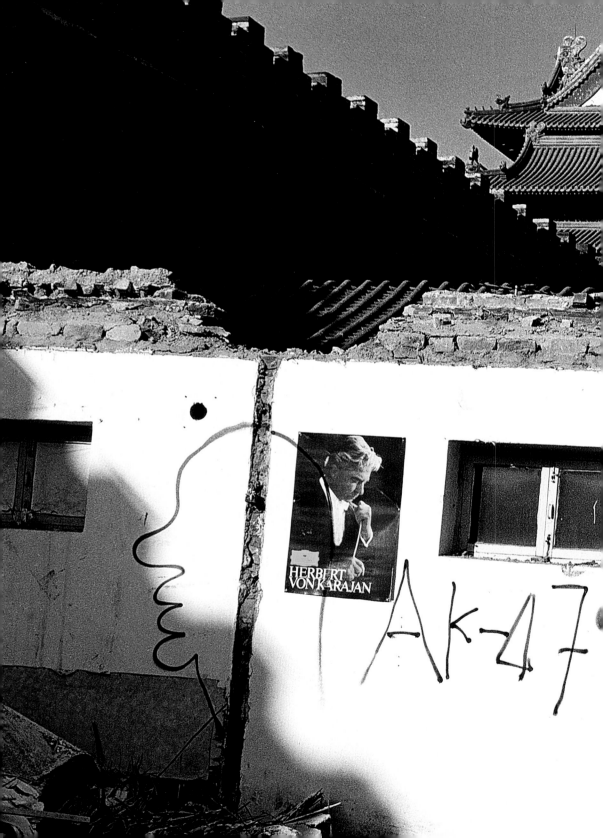

HERBERT
VON KARAJAN

AK-47

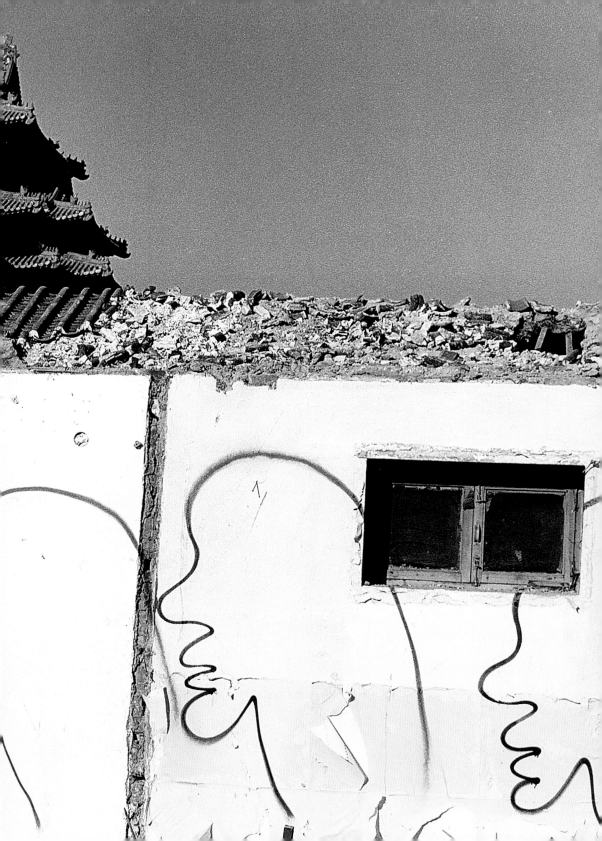

# 5.

The Chinese artists' diaspora
is returning to China.

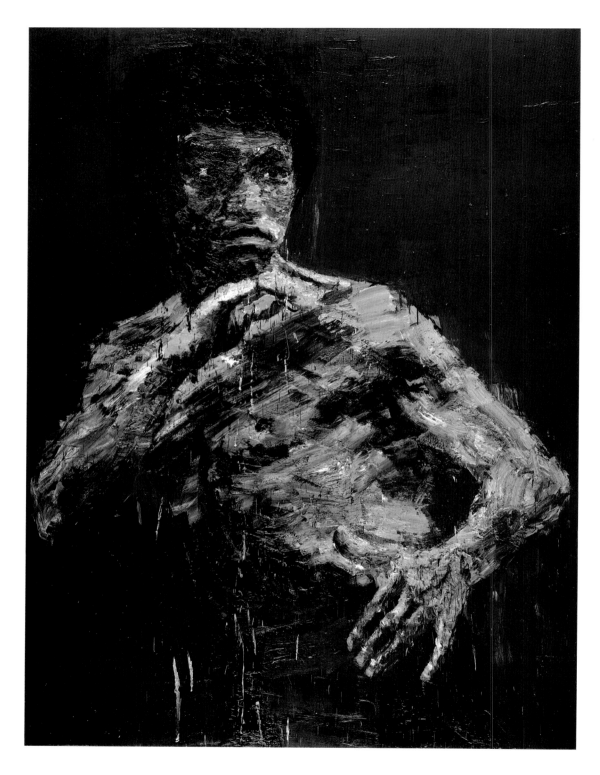

**66** The Chinese artists' diaspora is returning to China.

In 2001, the artist Cai Guo-Qiang—who now lives in New York—was invited to stage one of his signature pyrotechnic displays during the Asia-Pacific Economic Cooperation (APEC) summit meeting in Shanghai. It was unlike anything the city had seen, with a synchronized display of fireworks set off from the roofs of buildings along the Bund (the European-style thoroughfare along the Huangpu River) and The Oriental Pearl TV Tower in Pudong Park on the opposite embankment. This event marked a turning point

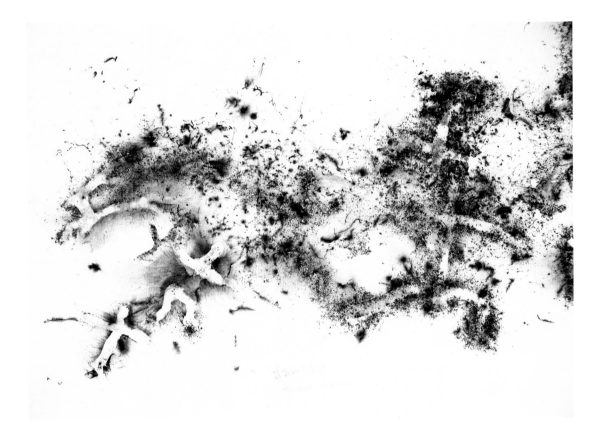

▲ **Cai Guo-Qiang** | *Ancient Branding* (detail) 2003 Gunpowder on paper 400 × 1000 cm
Courtesy of Asia Society Museum, New York

◀ **Yan Pei-Ming** | *Bruce Lee* 1999 Oil on canvas 400 × 300 cm Courtesy of Private Collection

■ ( Page 68 ) **Xu Bing** | *Square Word Calligraphy Study Sketch* (detail) 1994 Ink on paper 47 × 31.1 cm
Courtesy of Xu Bing Studio

好對對起事

同字母最

芳例而相

的是結構字

乃是重要

是收尾

字

尾字

右結構字的

字了可做為左

800

in official attitudes toward contemporary art and expatriate Chinese artists; until then, Cai had been more or less prohibited from showing his work in the country since emigrating to Japan (and later the United States) in 1986. Soon after the APEC performance, Cai was the subject of an exhibition at the Shanghai Art Museum. This honor was read by many as a signal that overseas Chinese artists were welcome to exhibit their work in the country's official museums.

Cai had left China during a period sometimes described by Chinese historians as a "leave the country" fever. The mid- to late 1980s was a time when many Chinese artists decided to pursue opportunities abroad, especially after Tiananmen Square. Leading figures in the development of Chinese experimental art went elsewhere, including Chen Zhen, Wang Keping, Yang Jiechang, Li Shuang, Yan Pei-Ming, Wang Du, and Huang Yong Ping, who settled, for the most part, in Paris. Other expatriates, such as Xu Bing, Cai Guo-Qiang, Gu Wenda, Ai Weiwei, Yan Li, Zhong Acheng, Shao Fei, and Zhang Hongtu made

▲ **Wang Du** | *Défilé* 2000 Mixed media installation Dimensions variable
Collection of the FNAC (Fonds National d'Art Contemporarin) Courtesy of Galerie Lauren Godin, Paris
▶ **Wenda Gu** | *Psuedo Character* 1989 Ink on paper 280 × 175 cm Courtesy of the artist

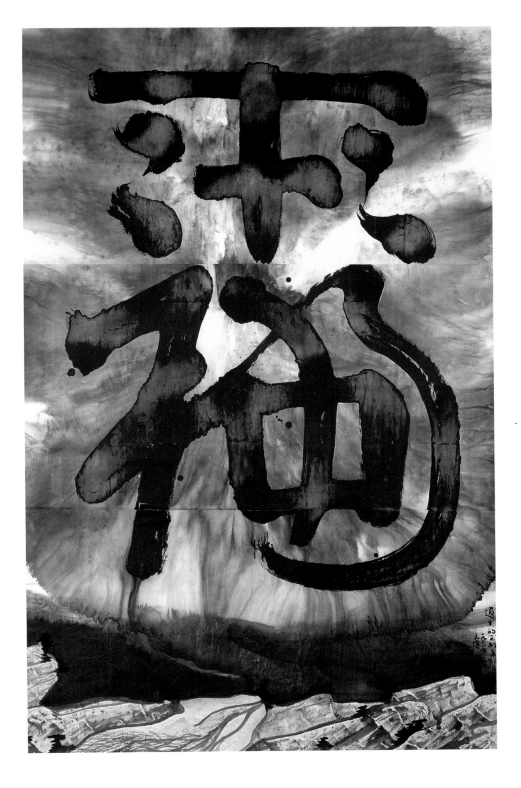

their homes in New York. Qu Leilei left for England, while Huang Rui and Ma Desheng settled in Japan and Switzerland respectively.

By the early 1990s, the Chinese contemporary art world was divided into two communities: those living in exile and those who remained in mainland China. There were occasional crossovers between the two, generally when expatriate and mainland artists were included in the same exhibitions abroad. One such exhibition was *Inside Out: New Chinese Art*. Presented at the Asia Society in New York in 1998 and the San Francisco Museum of Modern Art in 1999, it was crucial in providing a foundation for the study of Chinese contemporary art in the United States, and in paving the way for wider museum and art-market acceptance.

The two art worlds inside and outside China operated independently until roughly 2000. In the period just before China joined the World Trade Organization in 2001, government attitudes toward experimental art practices started to ease and exhibitions began to appear more frequently. On the heels of Cai Guo-Qiang's 2001 invitation to exhibit there, it became evident that the government was interested in reclaiming, at least to some extent, China's expatriate artists, many of whom had built international reputations during their years abroad. In 2005, Cai was invited to curate the official Chinese presentation at the Venice Biennale, one of the art world's most prestigious events. Other artists were lured back to China with promises of exhibitions and involvement in new art, architecture, and curatorial projects. Relaxed travel restrictions and the apparent official acceptance of experimental art encouraged others to return. Artists who had lived outside China for nearly two decades began to visit with greater frequency. Yan Pei-Ming, Wenda Gu, and Zhang Huan established studios in Shanghai, and others returned periodically to have their works fabricated in factories across China. Ai Weiwei, Liu Dan, Chen Danqing, Xing Danwen, Wang GongXin, Lin Tianmiao, and Wang Zhiyuan returned to China permanently.

▶ **Chen Zhen** | *Un Village sans frontieres* 2000  Chair, candles  77 × 41 × 42 cm
Courtesy of Galleria Continua, San Gimignano—Beijing

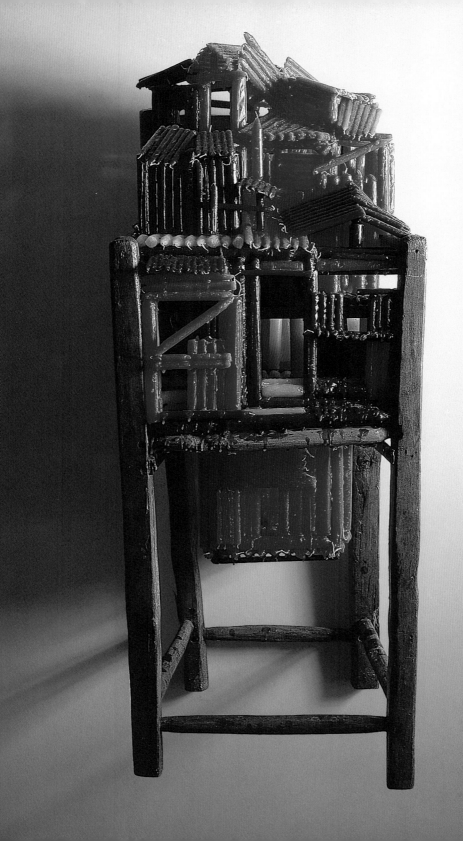

# 6.

## Contemporary art museums in China are on the rise.

*T*here are presently only a handful of contemporary art museums in China. Most are private initiatives, as there are few public collections of Chinese contemporary art in China itself. Until recently, state-run Chinese modern and contemporary museums have operated as temporary exhibition halls, rather than acquiring and displaying collections of their own.

Among the public museums that show (and have begun to collect) Chinese contemporary art are the National Art Museum in Beijing, the Shanghai Art Museum in Shanghai, the Guangdong Museum of Art in Guangzhou, and OCT Contemporary Art

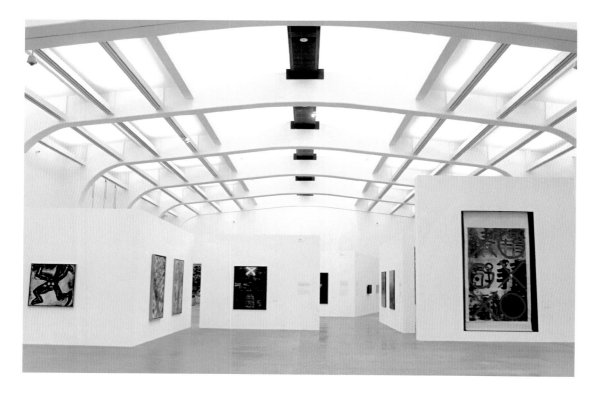

▲ Interior of exhibition hall, Ullens Center for Contemporary Art, Beijing  Courtesy of UCCA
▶ **Lin Tianmiao** | *Focus Series* 2000-2002  Thread and digital print on canvas  152 × 127 cm
  Courtesy of the artist

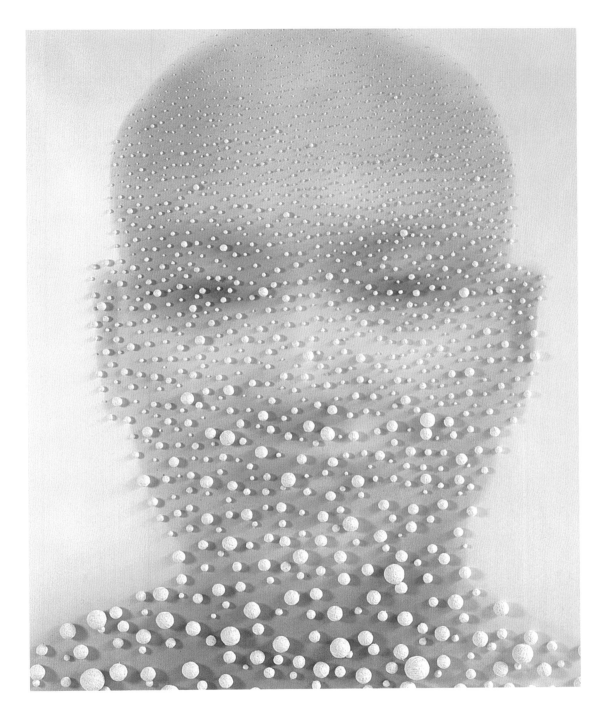

Terminal (OCAT) in Shenzhen. Private contemporary art museums include the Shanghai Museum of Contemporary Art, and the Duolun Modern Art Museum (also in Shanghai). Beijing is home to the Today Art Museum and the Ullens Center for Contemporary Art, a museum in the 798 gallery district. Housed in a renovated factory designed by French architect Jean-Michel Wilmotte, the Ullens Center has one of the most substantial collections in the country. Other private institutions, like the Square Art Museum in Nanjing and the Zhengda Modern Art Museum in Shanghai—both owned by prominent local businessmen—are actively collecting contemporary art.

The Chinese government has announced ambitious plans for new museums throughout the country. Given that contemporary art is already widely exhibited, there is no reason to think that it will be excluded from these new ventures. The Beijing Olympics and the Shanghai Expo in 2010 have fuelled this growth to some extent. But there is also a growing awareness that substantial holdings of Chinese contemporary art (as well as antiquities) are currently in private and public collections outside China. By building museums and actively collecting art, the Chinese government is putting mechanisms in place to attract donations of works from artists and foreign collectors.

▲  **Song Dong** | *Stamping the Water* 1996  Photographs  36 parts  62 × 42 cm each
Courtesy of Asia Society Museum, New York

▶  **Zhan Wang** | *Artificial Rock No. 40* 2001  Stainless steel  Dimensions variable  Courtesy of Private Collection

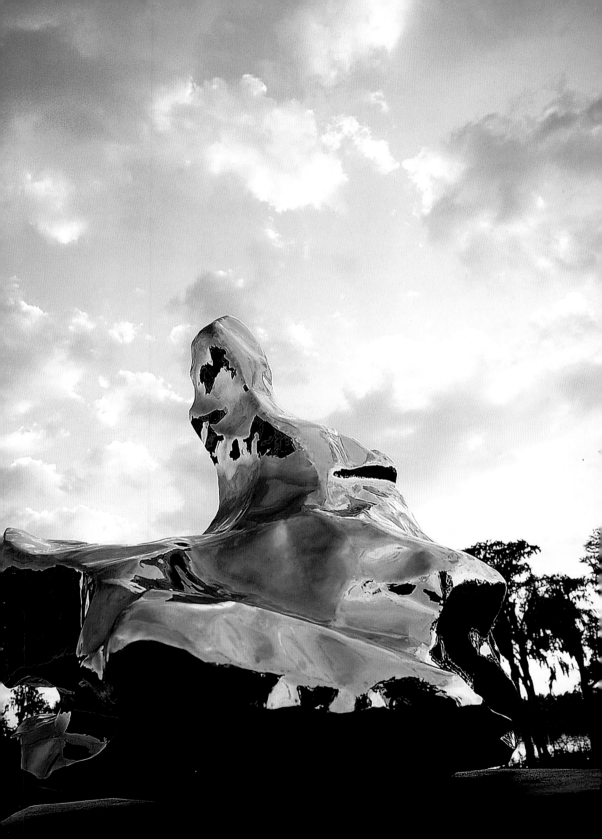

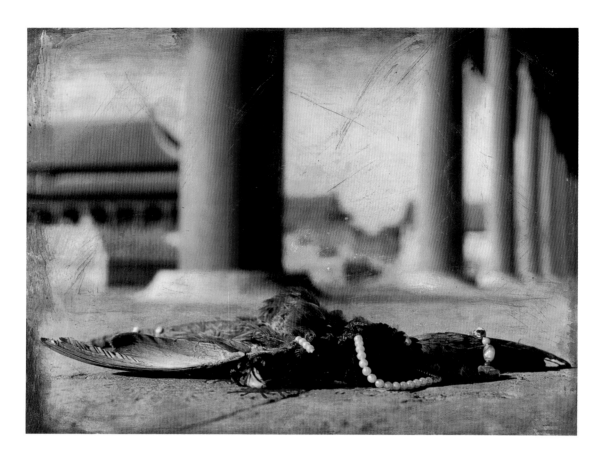

Some local governments are also establishing contemporary art museums. Among the first is the Song Zhuang Art Museum on the outskirts of Beijing, funded by the government of the Song Zhuang district. In 2007, a local government in Sichuan province announced that it was prepared to build museums dedicated to the work of eight leading Chinese artists—Zhang Xiaogang, Wang Guangyi, Fang Lijun, Yue Minjun, Zhou Chunya, He Duoling, Zhang Peili, and Wu Shanzhuan—in the city of Dujiangyan, near the provincial capital of Chengdu. A smaller number of successful artists also have plans to open (or have opened) their own museums, including such artist couples as Song Dong and Yin Xiuzhen, Lin Tianmiao and Wang GongXin, and Rong Rong and Inri, whose Three Shadows Photography Arts Center opened in Beijing in 2007.

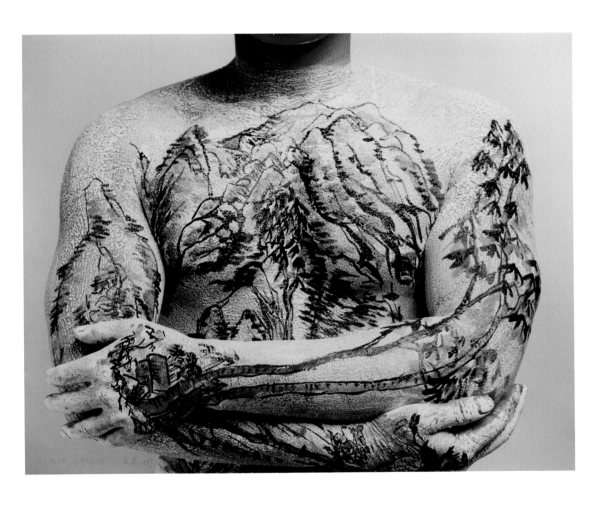

▲  **Huang Yan** | *Chinese Landscape – Tattoo*  1999  Color photograph  80 × 100 cm  Courtesy of Private Collection
◄  **Hong Lei** | *Autumn in the Forbidden City*  1998  Color photograph  104 × 127 cm  Courtesy of Private Collection

# 7.

The world is collecting
Chinese contemporary art.

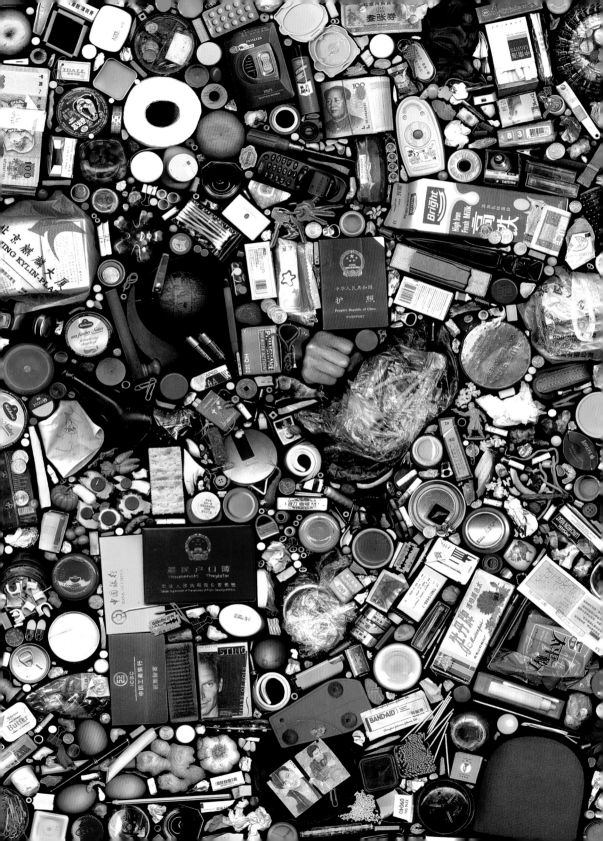

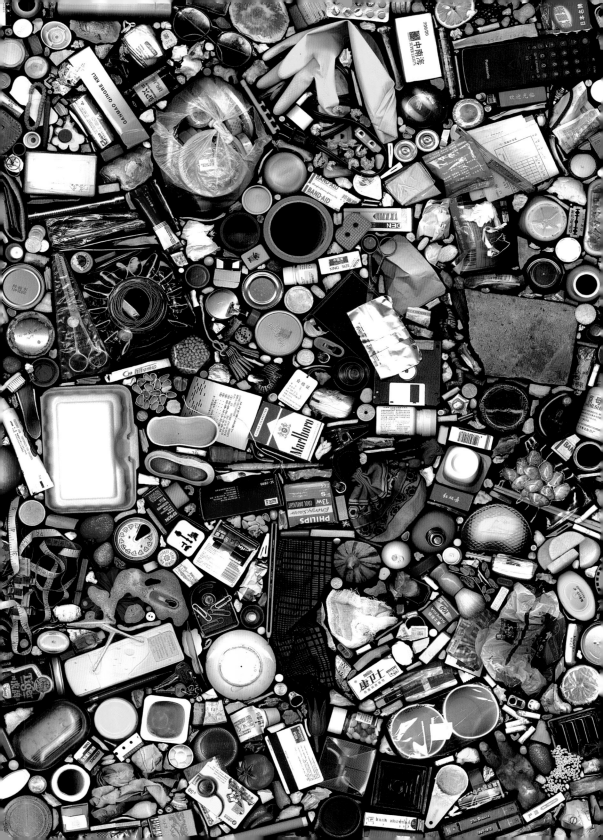

ntil recently, the most significant collections of contemporary Chinese art were in foreign hands. Early collectors had the foresight to make key acquisitions, amassing outstanding holdings well before many had begun to consider Chinese contemporary art as a field of interest.

Swiss-born Uli Sigg was one such prescient collector. In 1980, he had been involved in China's first official joint business venture with a foreign company, and served as Swiss ambassador to China in 1995-98. Today, his collection numbers well over a thousand works. Belgian collector Baron Guy Ullens, whose father had been a diplomat in China, also had business dealings in the country. Though he began his collection with antiquities, nearly a decade ago he turned his attention to Chinese contemporary art. Both

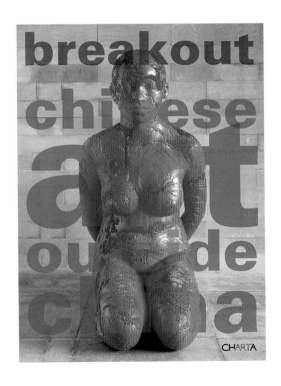

■ (Page 84) **Hong Hao** | *My Things No. 1* (detail) 2001-2002  Color photograph  127 × 216 cm
Courtesy of the Sigg Collection

▲ Cover of *Breakout: Chinese Art Outside China*  2007

◀ **Ai Weiwei** | *Map of China*  2003  Wood  78 × 98 × 110 cm  Courtesy of Private Collection

collectors have supported the emerging art scene; in 1997, Ambassador Sigg created an international juried prize for Chinese artists, and in 2002 Baron Guy and his wife Myriam Ullens established a foundation to support research in contemporary Chinese art. In 2007, they opened the Ullens Center for Contemporary Art in Beijing. In the United States, Kent and Vicki Logan, Eloisa and Chris Haudenschild, and Howard and Patricia Farber assembled important collections over the past few years; recently, Kent and Vicki Logan donated much of their Asian contemporary art collection to the San Francisco Museum of Modern Art and the Denver Art Museum.

An increasing number of contemporary art collectors in China now vie with international buyers for the best new works. Among them is Guan Yi, who displays his impressive collection of large-scale paintings and sculptures in a warehouse on the outskirts of Beijing. Museums in the United States and around the world have continued to acquire Chinese contemporary art. In 2007, the Asia Society Museum (where I am the director) announced a contemporary art collecting initiative with a strong focus on Chinese art,

particularly video art and photography. The San Francisco Museum of Modern Art; New York's International Center of Photography, Museum of Modern Art, and Metropolitan Museum of Art; the Museum of Fine Arts, Houston; the Smart Museum of Art in Chicago; the Mori Art Museum and the Asian Art Museum in Japan; the Queensland Art Gallery in Brisbane, Australia; and the Centre Pompidou in Paris are among the museums acquiring and showing Chinese contemporary art. Steps are also underway to preserve the art historical record of the present era, with the establishment of research centers such as the Asia Art Archive in Hong Kong and the contemporary archives at Peking University in Beijing.

▲  Wenda Gu's work on the cover of *Art in America* magazine, March 1999
◀  Contemporary Chinese art collector Guan Yi's private museum, Beijing

# Conclusion

Contemporary Chinese art is here to stay. Overcoming an earlier era of censorship and lack of official support, Chinese artists have established themselves in the international art world. The Chinese government is now demonstrating more support for artists, from the local and provincial levels to the national.

Judging by the dynamism of Chinese art schools, the future also looks bright. Cutting-edge artists once shunned or persecuted by the authorities are teaching once again. Experimental practices such as installation, video, and performance art are now integral to the curricula at many leading art schools, including the Central Academy of Fine Arts in Beijing and The China Academy of Art in Hangzhou. Expatriate artist Xu Bing was recently appointed vice president of the Central Academy of Fine Arts, a key appointment that will have significant impact on curriculum development. At The China Academy of Art, a new media lab and an interdisciplinary approach to art education known as the Total Art Department are encouraging experimentation across disciplines. The media lab is headed by Zhang Peili, a veteran video artist whose work was once dismissed by the official Chinese academy because at the time, works in video were not considered art.

This turnaround in official attitudes encapsulates many of the changes that have taken place in Chinese contemporary art over the past three decades. The decade of the 1980s was one of liberalization, when artists experimented for the first time with new art styles and media. The 1990s saw the internationalization of Chinese contemporary art, as expatriate artists pursued opportunities abroad while those in China responded to renewed repression by showing their work in private spaces and creating work especially for exhibitions abroad. As the country started to take a more prominent role in the global economic community, a thaw occurred in official attitudes toward experimental art. This made it easier for artists to exhibit their work and, coupled with a newly envigorated domestic art market, encouraged many expatriate artists to return to China to live and work.

All sectors of the art world in China have experienced expansion and growth, which has seen a convergence of domestic and international interests in collecting and now preserving art works. With this, Chinese contemporary art is entering a period of maturity

◀ **Wang Qingsong** | *Requesting Buddha* 1999 Color photograph 180 × 110 cm Courtesy of Private Collection

where there is a growing scholarly consensus on its art history—that is, the identification of key artists, styles, and movements. For all involved, this has meant a greater focus on China rather than on the Chinese diaspora. There is no sign of this abating. We should anticipate more Chinese artists entering the international arena and exhibiting their work in museums and galleries worldwide, especially younger artists working in photography and video art.

But perhaps the greatest change will occur within China. It is likely that, as important artists continue to emerge and contemporary art museums attract increased attention for their activities, greater numbers of Chinese collectors will acquire experimental art. At the same time, the number of students enrolling in art schools has also increased.

There are those who claim that, just as the 20th century was known as "the American century," the 21st will belong to China. This remains to be seen; but we can assume that the potential of Chinese contemporary art has yet to be fully realized.

▲ **Cang Xin** | *Communication Series* 1999 Color photograph 100 × 80 cm Courtesy of Private Collection
◀ **Yue Minjun** | *Contemporary Terracotta Warriors* 2005 Bronze 55 × 182 × 55 cm Courtesy of the artist
■ ( Page 96 ) **Yan Lei** | *Fifth System* 2003 Oil on canvas 150 × 200 cm Courtesy of the artist

# Artist Biographies

## AI WEIWEI

Ai Weiwei (born 1957, Beijing) is a conceptual artist, curator, cultural advisor, and architect. In 1979, he was a founder of "The Stars" (*Xing Xing*), one of the first avant-garde art groups in modern China. During the 1980s and early 1990s he lived in New York, where he studied at the Art Students League and the Parsons School of Design. Returning to China in 1993, he co-founded the China Art Archive & Warehouse (CAAW), a nonprofit loft-gallery in Beijing where he serves as artistic director. Ai's work has been shown in museums and galleries internationally, as well as in the 48th Venice Biennale (1999), Documenta XII (2007), and other international art events. As a curator, he is known for cutting-edge exhibitions, such as *Fuck Off*, which he co-curated in 1999 as a provocative counterpoint to the Shanghai Biennale. In the early 2000s, Ai collaborated with the acclaimed Swiss architects Herzog & de Meuron on the winning design for the National Stadium project for the Beijing Olympics. In 2008 he received the Chinese Contemporary Art Award, established in 1998 by Swiss Ambassador and collector Uli Sigg, for Lifetime Contribution.
( Image / Pages 59, 86 )

## CAI GUO-QIANG

Cai Guo-Qiang (born 1957, Quanzhou, Fujian Province) was educated in stage design at the Shanghai Drama Institute from 1981 to 1985. Gunpowder is his trademark medium, from drawings and paintings made by igniting carefully monitored explosions on paper and canvas to massive explosion events like the *Projects for Extraterrestrials*. He is also known for sculptural installation works such as *Borrowing Your Enemy's Arrows* (1998), a massive wooden boat riddled with arrows that recalls a legendary tactic of an ancient Chinese general. Cai has had many solo exhibitions, including *Cai Guo-Qiang on the Roof: Transparent Monument* at the Metropolitan Museum of Art (2006) and *Cai Guo-Qiang: I Want to Believe* at the Guggenheim Museum in New York (2008). He was awarded the International Golden Lion prize at the 48th Venice Biennale (1999), and curated the first China Pavilion at the 51st Venice Biennale (2005). He was the Chief Special Effects Designer for the 2008 Beijing Olympics' creative team. Cai lives in Brooklyn.
( Image / Pages 50, 67 )

## CANG XIN

Performance artist Cang Xin (born 1967, Suihua, Heilongjiang Province) studied in the literature department of the Tianjin Academy of Music. A self-fashioned shaman, he views his art as a means of promoting harmony and balance. In one continuing series, *Changing Identity*, Cang photographs himself dressed in the clothing of the individuals standing next to him. They wear nothing but their underwear; in one image from the 2006 *London Exchange Identity Series*, for instance, Cang is dressed as one of the Queen's guards. In *Communications*, a continuing piece begun in 1996, Cang uses his tongue to connect with a range of materials in different locations, including money, animals, and glaciers. His works have been exhibited in Japan, Singapore, Australia, Italy, France, and throughout the U.S. Cang currently lives in Beijing.
( Image / Page 95 )

## CAO FEI

Cao Fei (born 1978, Guangzhou) graduated from the Guangzhou Academy of Fine Arts in 2001. She works in a range of media—video, photography, performance, installation, and Internet art—exploring such topics as electronic entertainment, consumer culture, and China's rapid urbanization. Some of her recent works involve digital utopias and fictional game characters like "China Tracy," a virtual female who lives in Second Life, a multi-user online environment. Cao frequently collaborates with Chinese artist Ou Ning; together, they produced *The San Yuan Li Project* for the 50th Venice Biennale (2003). In 2004 they co-founded the Alternative Archive, a platform that connects contemporary art, film, music, theater, design, urban studies, and publications. Cao exhibits widely, and in 2006 was awarded Best Young Artist by the Chinese Contemporary Art Awards (CCAA). She lives in Guangzhou Province.
( Image / Page 38 )

## CHEN DANQING

When he was just seventeen years old, Chen Danqing (born 1953, Shanghai) settled in the countryside of northern Jiangsu Province and taught himself to

paint. He stayed there for seven years before traveling to Tibet, which had a lasting influence on his art. Chen was later admitted to the postgraduate painting program of the Central Academy of Fine Arts in Beijing, graduating in 1980. He first came to prominence for his realist depictions of the Tibetan people. Later subjects include Chinese towns and countryside, nudes, and still lifes evoking Chinese and Western art history. Chen lived in New York for almost twenty years before returning to China in 2000. He now lives in Beijing.

## CHEN ZHEN

Chen Zhen (born 1955, Shanghai; died 2000, Paris) came of age during the Cultural Revolution. He emigrated to Paris in 1986 and attended the École Nationale Supérieure des Beaux-Arts and the Institut des Hautes Études en Arts Plastiques. There, he abandoned his previous interest in painting for installation art. One of the first major installation artists in contemporary China, he combined traditional Chinese philosophy with Western practices, focusing on concepts of organic wholeness, healing, and spirituality. His installation *Autel de Lumiere* (2000), for instance, consists of three wooden children's chairs bearing house-shaped constructions made of colored candles—a familiar Chinese symbol for an individual's lifespan. Other works are filled with references to the body, medicine, sickness, and healing, reflecting his own lengthy battle with the rare blood disease that eventually claimed him. Chen's work is still regularly exhibited internationally, including a 2007

retrospective at the Kunsthalle in Vienna.

( Image / Page 73 )

## CUI XIUWEN

Cui Xiuwen (born 1970, Harbin, Heilongjiang Province) studied at the Fine Arts Department of Northeast Normal University, later graduating from the painting department of the Central Academy of Fine Arts in Beijing. Cui is a leading female artist whose experimental photography and video works confront issues of sexuality and gender, prostitution, pregnancy, and child pornography. Her work has been exhibited at the Tate Modern in London, the Pompidou Center in Paris, and the International Center of Photography and the Asia Society in New York. She lives and works in Beijing.

## FANG LIJUN

Fang Lijun (born 1963, Handan, Hebei Province) graduated from the Print Department of the Beijing Academy of Art in 1989. A leader of the post-1989 Cynical Realism movement, Fang is known for his large-scale depictions of bald-headed, clone-like figures, mouths open as if crying out, massed against anonymous backgrounds of sky, clouds, or water. From paintings and woodcut prints, these depictions have expanded to include groupings of sculpted heads and figures. In a recent departure from this motif, a three-panel work from 2007 portrays dreamlike flocks of exotic birds and swarms of brightly colored fish massing at Tienanmen Square. Fang has exhibited internationally since the early 1990s, including shows at New York's Museum of

Modern Art, the Nanjing Museum in China, and the National Gallery of Jakarta, Indonesia. He divides his time between Beijing and Yunnan Province.

( Image / Page 26 )

## FENG MENGBO

Feng Mengbo (born 1966, Beijing) studied design and printmaking at the Central Academy of Fine Arts in Beijing under the artist Xu Bing. Since the late 1980s, his work has examined Chinese popular culture and its underlying politics, often mixed with artifacts of Western pop culture. In the early 1990s he began exploring computer art, creating digital slide shows, CD-ROMs, and video games. His 1997 CD-ROM, *Taking Mount Doom by Strategy*, uses film and stage versions of *Taking Tiger Mountain by Strategy*, a Cultural Revolution-era Chinese opera, grafting them onto the popular Western video game *Doom*. Feng's 2001 online art project for Dia, *Phantom Tales*, is still accessible on the Dia website (diacenter.org). He participated in the 45th Venice Biennale (1993) Documenta X (1997), and other international events and exhibitions. He lives in Beijing.

## GENG JIANYI

Geng Jianyi (born 1962, Zhenzhou, Henan Province) studied oil painting at the Zhejiang Academy of Fine Arts. Among the first contemporary artists to emerge in the 1980s, Geng painted faces grimacing with forced laughter, which were a significant influence on artists such as Yue Minjun and Zeng Fanzhi. Along with continuing experiments in portraiture, Geng's recent

works have included photographic depictions of water and book-based sculptural objects. International exhibitions include *The Real Thing: Contemporary Art from China*, IVAM, Valencia, Spain (2008), *Zooming into Focus*, Beijing National Museum of Art (2005), and the 5th Shanghai Biennale (2004). Geng lives in Hangzhou and teaches at the China Academy of Fine Arts.
( Image / Page 8 )

## GU DEXIN

Gu Dexin (born 1962, Beijing) is a self-taught artist who, since coming to prominence in the 1980s, has pushed the boundaries of taste with provocative installation works. Sexuality and decay are his primary themes, explored in such pieces as *March 4, 2006*, a flotilla of battery-operated toy cars topped by plastic sex toys, or *11/4/2000*, a mock-art installation featuring a red carpet, a gold-framed artwork (actually more red carpet), and for contemplating it, a sofa upholstered in raw meat. A 2001 work, created for the Hamburger Banhof in Berlin, consisted of covering the front lawn with apples and leaving them to rot. In addition to installation art, Gu has worked in video, sculpture, photography, and embroidery. He lives in Beijing.

## WENDA GU

Best known by the Westernized form of his name, Gu (born 1955, Shanghai) studied ink painting under modern master Lu Yanshao at the Chinese Academy of Art in Hangzhou. In the early 1980s, he began taking traditional ink-brush technique in new directions with large, near-abstract paintings and

installations. Gu is best known for monumental pieces based on pseudo-Chinese ideograms that, although depicted as if they were ancient traditional characters, are actually meaningless. Moving to New York in the late 1980s, he began *United Nations*, a series of installations involving banners, curtains, and large-scale forms made from human hair, often featuring unreadable text in made-up "languages." To date, he has created more than 25 site-specific installations in the series. Gu's work has been exhibited in museums in Mexico, Australia, Korea, England, Israel, the United States, and other countries. Based in New York City, he also maintains a studio in Shanghai.
( Image / Page 71 )

## HAI BO

Hai Bo (born 1962, Changchun, Jilin Province) graduated from the Fine Art Institute of Jilin in 1984 and later studied at the Central Academy of Fine Arts in Beijing. Hai Bo is a conceptual photographer whose work explores themes of history and memory, impermanence, and the passage of time. Much of his work is inspired by formal portrait photographs, a mainstay of Chinese popular culture. Hai Bo pairs group photos, taken in the 1970s during the Cultural Revolution, with contemporary re-creations that depict the subjects in the same relative positions. Empty spots in the re-created groupings evoke time's passage and hint at the social upheavals of that cataclysmic era. For the past several years he has photographed landscapes, often depicting the same view through

the seasons. He lives and works in Beijing.
( Image / Page 28 )

## HE DUOLING

He Duoling (born 1948, Chengdu, Sichuan Province) received his M.A. in painting from the Sichuan Academy of Fine Arts in 1982. Since the early 1980s, He has worked in a classical realist style, focusing primarily on nudes, melancholy landscapes, and depictions of ethnic minorities in the Chinese countryside. His work has been shown throughout China as well as in Taiwan, Germany, Holland, Japan and Portugal. He Duoling currently teaches at the Sichuan Academy of Fine Arts in Chongqing.

## HONG HAO

Hong Hao (born 1965, Beijing) graduated from the printmaking department of Beijing's Central Academy of Fine Arts in 1989. Though formally diverse, his work is characterized by a zest for cataloguing and reassembling reality. His *Selected Scriptures* series of silkscreen prints, done in the early 1990s, at first glance looks like pages from an old-fashioned atlas—except that Hong rearranged the geography to reflect the comparative strength of global corporations, or of military power. The large-format digital photographs in the *My Things* series (begun 2001) are made of individually photographed items in the artist's possession, dynamically arranged by shape and color, almost like mosaic tiles. While many of these works implicitly critique consumer culture, some—like *My Things No. 6 (The Hangover of*

*Revolution in My Home)*, done in 2002, hints at the shadows still cast by the Cultural Revolution. Hong's work has been shown throughout Europe, Asia, and North America. He lives in Beijing.
**( Image / Pages 40, 84 )**

## HONG LEI

Hong Lei (born 1960, Changzhou, Jiangsu Province) studied engraving at the Central Academy of Fine Arts and later graduated from the Nanjing Academy of Arts in 1987. He creates photo-based works that incorporate ancient design motifs, including imperial court images from the Song Dynasty (960-1279). Hong's serene images are slightly mysterious, but their composition and at times saturated colors give them a distinctly contemporary look. Hong's work has been exhibited in New York, Poland, Guangzhou, Shanghai, and Seoul. He lives in Beijing.
**( Image / Page 80 )**

## HUANG RUI

Huang Rui (born 1952, Beijing) is a pioneer of contemporary Chinese art, first making a name for himself as a member of The Stars (*Xing Xing*), the avant-garde artists' group that emerged in 1979. In the early 1980s Huang was primarily a painter, but later expanded to performance art, installation, photography, and printmaking. Though his work is conceptual, much of it offers pointed commentary on social and political conditions in China—as in *Texts are the Legacy of Great Thought!*, a 2007 installation in New York that presented, as a work of art, a new Chinese edition of Marx and Engel's *Communist Manifesto*. As a result, he is among the country's most

intensely censored artists. Huang lived in Japan for eight years before returning to China in 1992; facing government pressure, he left again in 1994, returning in 2001. His work has been shown in Asia, Europe, and the U.S. Huang was among the first artists to take studio space in Beijing's 798 district. He continues to live in Beijing.

## HUANG YAN

A sculptor, painter, photographer, and performance artist, Huang Yan (born 1966, Jilin Province) studied at the Changchun Normal Academy. He is known for his "tattoo landscape" series, featuring scenes from classical Chinese painting re-created on his own face and body and those of others. Huang has exhibited extensively in China, Europe, and the United States. He divides his time between Changchun and Beijing.
**( Image / Page 81 )**

## HUANG YONG PING

Huang Yong Ping (born 1954, Quanzhou, Fujian Province) graduated from the Zhejiang Academy of Fine Arts in Hangzhou in 1982. He was one of the founding members of the Xiamen Dada, a conceptual art group strongly influenced by Marcel Duchamp and Joseph Beuys. Huang was an active and influential artist in China throughout the 1980s; in 1989, he moved to France following his participation in the *Magiciens de la Terre* exhibition at the Pompidou Center. Huang's work juxtaposes Chinese and Western concepts and symbols, often with a Dada-like sense of absurdity. One of his most reknowned works is *'A History of*

*Chinese Painting' and 'A Concise History of Modern Painting' Washed in a Washing Machine for Two Minutes* (1987/1993), in which he ran these two texts through a washing machine, producing an illegible lump of art history. Huang has participated in many international art exhibitions, including the Shanghai Biennale (2000) and the 50th Venice Biennale (2003). His 2005-2007 exhibition, *House of Oracles: A Huang Yong Ping Retrospective*, was presented at the Walker Art Center in Minneapolis, at MASS MoCA, and the Vancouver Art Gallery. He lives in Paris.
**( Image / Pages 20 )**

## LI SHAN

Li Shan (born 1942, Lanxi County, Heilongjiang Province) graduated from the Art Department of the Shanghai Theater Academy in 1968. He is a principal artist of the Political Pop movement, which emerged in the early 1990s. His best-known works feature a stylized young Mao, sometimes wearing lipstick or sporting a lotus flower, set against a bright background. Moving beyond Mao portraits, Li uses decorative and folk art motifs to explore ambiguities of sex, gender, and species: works in his 2005 *Reading* series, for instance, depict fantastical insects collaged from human body parts. Li's art has been exhibited internationally, including *'85 New Wave – The Birth of Contemporary Chinese Art* at the Ullens Center for Contemporary Art, Beijing (2007), the First Guangzhou Triennial, (2002), and the 45th Venice Biennale (1993). He lives in Shanghai.

## LI SHUANG

Li Shuang (born 1957, Beijing) was raised during the Cultural Revolution, which has been an important influence on her art. She was the only female member of "The Stars" (*Xing Xing*), widely recognized as the first avant-garde artists' group in contemporary China. The subjects of her work are often serene women with idealized features, painted in soft tones with traditional objects—orchids, classical Chinese furniture, bamboo stalks—in the background. Imprisoned for two years in the early 1980s for cohabiting with a French diplomat, upon her release she moved to Paris and married her fiancé. Her work has been shown extensively in Europe, and in 2007 she had solo shows in Paris and Singapore. Li Shuang lives in Paris.

## LIN TIANMIAO

Lin Tianmiao (born 1961, Taiyuan, Shanxi Province) graduated from the Fine Art Department of Capital Normal University in 1984. From 1986 to 1994, she lived in the United States, where she was influenced by the work of such artists as Ann Hamilton and Kiki Smith. Lin started out as a textile designer, and that background is readily apparent in her installation work, which frequently combines textile materials with photography and video. In some pieces, Lin encases ordinary objects in thread until the original forms give way to ghostlike echoes of their former selves. In other works, she incorporates small stitchings and balls of thread over oversized digital portraits. Lin has also collaborated with husband Wang GongXin on photography and installation works. She lives and works in Beijing.

( Image / Page 77 )

## LIN YILIN

Lin Yilin (born 1964, Guangzhou) studied sculpture at the Guangzhou Academy of Fine Arts, graduating in 1987. In 1990 he and three other Guangzhou artists (Liang Juhui, Xu Tan, Chen Shaoxiong) founded the "Big-Tail Elephant Group," which produced installation, performance, and public art in response to the radical urbanization taking place in Guangzhou (formerly known as Canton), in the Pearl River Delta region of China. In his own art, Lin's most frequent materials include bricks and concrete blocks. He uses these everyday objects in performance and installation works that comment on the individual's relationship to modernization. Lin has participated in many international exhibitions, including Documenta XII (2007), The 5th International Ink Painting Biennale of Shenzhen (2006), and the Second Guangzhou Triennial (2005). In 2001, Lin Yilin moved to the United States. He currently divides his time between New York and Guangzhou.

( Image / Page 57 )

## LIU WEI

Liu Wei (born 1965, Beijing) graduated from the Printmaking Department of the Central Academy of Fine Arts in 1989. Coming to prominence in the early 1990s as a Cynical Realist artist, Liu re-examined Chinese political history through such paintings as *Spring Dream in a Garden: Dad in Front of the TV* (1992), which depicts a figure in military uniform looking askance at a televised performance of traditional Chinese opera, and *New Generation* (1992), which poses a pair of blank-faced infants before a portrait of Mao, who already appears to be receding into history. Liu's later work encompasses attractive women and distant landscapes, as well as sweating, pink-faced men with frothing mouths and misplaced sexual organs. His art has been exhibited internationally since the early 1990s and was included in the groundbreaking 1998 exhibition, *Inside Out: New Chinese Art* (1998). He lives in Beijing.

( Image / Page 33 )

## LIU XIAODONG

Liu Xiaodong (born 1963, Liaoning Province) earned a B.A. (1988) and an M.A. (1995) in painting from the Central Academy of Fine Arts in Beijing. He later received a second M.A. from the Academy of Fine Arts in Madrid, Spain. An acclaimed realist artist, Liu draws his subjects from everyday life, often basing his paintings on snapshots. Some of his most compelling works are images of people smoking, eating, or simply standing around. Liu was one of the earliest of the "New Generation" artists of the 1980s to gain international prominence. By 1989, his work was not only featured in the groundbreaking *China Avant-Garde* exhibition in Beijing, but had been shown in European museums, and he himself had spent time in the United States. His massive 2004 painting of the Three Gorges Dam depicts several figures standing along the banks above the infamous hydroelectric facility; the work gained international attention when

it set a world record at auction in late 2006. Liu lives in Beijing and teaches at the Central Academy of Fine Arts.

## MA DESHENG

Ma Desheng (born 1952, Beijing) is a self-taught artist who worked in industrial design and woodblock printing before turning to traditional Chinese brush painting. He was a founding member of "The Stars" (*Xing Xing*), widely regarded as the first avant-garde artists' group in contemporary China. Since 1986, Ma Desheng has lived in France. His recent works depict sculptural groupings of stones, set against vividly colored backdrops.

## MA LIUMING

Ma Liuming (born 1969, Huangshi, Hubei Province) graduated from the Hubei Academy of Arts in 1991 with a degree in painting. In the early 1990s he helped establish the "East Village" artists' community in Beijing. There, he began staging nude performance pieces as Fen-Ma Liuming, a personage with a woman's face and a man's body. His explorations of gender and sexuality, coupled with his nudity, made these early works particularly controversial. In 1994 he was arrested during a performance, held for two months, and charged with pornography. In addition to performance pieces, Ma works in painting and photography. He participated in the 1999 Venice Biennale, *Inside Out: New Chinese Art* (1998) and *Between Past and Future: New Photography and Video from China* (2004), both presented by New York museums. Ma Liuming lives and works in Beijing.

( Image / Page 54 )

## QI ZHILONG

Painter Qi Zhilong (born 1962, Inner Mongolia) graduated from the Central Academy of Fine Arts in Beijing in 1987. He is best known for his portraits of female Red Guards, dressed in uniform and smiling sweetly for the viewer. Reflecting Qi's roots in Political Pop, these works lend a provocatively girlish gloss to one of the most complex and difficult periods in modern Chinese history. Qi's art has been exhibited throughout China, as well as in Australia, Europe, and the United States. He lives in Beijing.

( Image / Page 48 )

## QIU ZHIJIE

An experimental artist working in a range of media, Qiu Zhijie (born 1969, Zhangzhou, Fujian Provence) is also a curator, art critic, and writer. He is a professor at the China Academy of Art in Hangzhou, where he serves as co-director of the Visual Culture Center. He is also artistic director of the Beijing 25000 Cultural Transmission Center, an experimental project space located in the 798 gallery complex. Primarily known for video and photography, Qiu has also made performance art, paintings, and prints. Among his most acclaimed works are the 1997 photographic *Tattoo Series*, in which he uses his own body—frequently shown blending into specially prepared backgrounds—to explore themes of collectivity, individuality, and social invisibility. Qiu has exhibited internationally at museums and galleries, and at the 50th Venice Biennale (2003) and the Shanghai Biennale (2004). He divides his time between Beijing

and Hangzhou.

( Image / Page 61 )

## RONG RONG

Rong Rong (real name Li Zhirong; born 1968, Zhangzhou, Fujian Province) studied photography at the Central Industrial Art Institute in Beijing. In the early 1990s, he was among the artists who established the "East Village" community on the outskirts of the city. In gritty black-and-white images, Rong Rong documented daily life in the East Village, as well as performances by such avant-garde artists as Zhang Huan and Ma Liuming. The images—often the only record of those groundbreaking performance events—were the first of Rong Rong's works to attract international attention. Later photographs focused on dilapidated and ruined buildings in Beijing, frequently arrayed with poetic visual elements, such as a woman's evening gown hung near an open fire. In 2000, Rong Rong began collaborating with the Japanese photographer Inri. In 2007, they opened the Three Shadows Photography Art Center, an international exhibition and education center in Beijing. Rong Rong lives in Beijing.

( Image / Page 25 )

## SONG DONG

Conceptual artist Song Dong (born 1966, Beijing) graduated from the Normal University in Beijing in 1989. Ranging from performance and installation art to photography and video, his work often uses humor to explore such themes as simultaneity and the future of urban life. In his 1998 video, *Clone*, for

instance, footage of the artist eating noodles is projected onto his naked body; watching himself in a mirror, he attempts to duplicate his previous gestures as they are projected on himself. A series of installations in the mid-2000s involved constructing miniature cities out of cookies— one such project, in a London department store, required 72,000 of them—then inviting the public to eat the artwork. For Song, these edible cities were a way of highlighting issues of consumer culture and runaway urban development in China and other parts of Asia. Song Dong's work has been exhibited internationally, including museums and galleries in Australia, the United States, France, Germany, Korea, and India. He lives in Beijing.

( Image / Page 78 )

## SUI JIANGUO

Sui Jianguo (born 1956, Qingdao, Shandong Province) was educated at the Shandong Institute of Fine Arts and the Central Academy of Fine Arts in Beijing. Early in his career he used rocks as the material for abstract sculptures: splitting them, hammering nails into them, or welding nets of rusted steel around them. In the late 1990s, he shifted gears, adopting two motifs for which he's now widely known: dinosaurs and the Mao jacket. His colorful dinos—made in oversized fiberglass versions or hordes of tiny figures— bring to mind the plastic toys mass-produced in China for export to the West. The iconic Mao jacket, emptied of its signature occupant, also appears in monumental fiberglass and in smaller-sized versions made of aluminum and other materials. At times, Sui

Jianguo combines the two motifs, as in *Sleeping Mao*, in which a fiberglass sculpture of the legendary leader reclines on thousands of tiny dinosaurs. Sui Jianguo has exhibited internationally. He is based in Beijing, where he heads the sculpture department the Central Academy of Fine Arts.

( Image / Page 10 )

## WANG DU

As a teenager, Wang Du (born 1956, Wuhan, Hubei Province) sketched and painted propaganda posters during the Cultural Revolution. He later studied sculpture at the Guangzhou Institute of Fine Arts, and eventually made his way to France. His work is a shrewd, slyly humorous blend of contemporary Western and Asian popular culture and sociopolitical currents—large installations that mix brightly colored plastic toys (made in China), sculptural busts of public figures, and recycled mass media, from mountains and tunnels of newspapers to oversized reproductions of magazine pages and banks of television screens. Wang participated in the 48th Venice Biennale (1999) and shows frequently in Europe. He lives and works in Paris.

( Image / Page 70 )

## WANG GONGXIN

Video artist and photographer Wang GongXin (born 1960, Beijing) graduated from Beijing Normal University in 1982. In the late 1980s and early 19990s, he lived and worked in New York with his wife, Lin Tianmiao. Returning to China in 1994, he created one of the country's first site-specific

installations in the courtyard of his traditional Beijing home: *The Brooklyn Sky* (1995), a video monitor buried face up, displaying footage of the sky above his previous home in New York. Wang's work is marked by a wry wit and impressive technical expertise. In the video *Karaoke* (2002), for instance, a man opens his mouth to reveal a full chorus of singers, one for each tooth. Produced with Lin Tianmiao, *Here? or There?* (2002), one of Wang's most noted works, is a complex, eerily compelling installation depicting an alien world in immersive detail. Wang has exhibited internationally in the United States, England, Germany, Belgium, Japan, and Australia. He lives in Beijing.

## WANG GUANGYI

Wang Guangyi (born 1957, Harbin, Heilongjiang Province) studied painting at the Zhejiang Academy of Fine Arts. He is best known for *Great Criticism*, a series of paintings and prints that have become icons of Political Pop, an influential movement that emerged in the late 1980s. A deft blend of Communist propaganda imagery and Western Pop Art, Wang's paintings are graphically striking critiques of both modern Chinese and Western consumer cultures—for instance, his *Chanel No. 5* (2001), which superimposes a group of Mao-jacketed young people saluting under the luxury brand's trademark. Wang's work has been exhibited widely in Asia and Europe, as well as in the U.S. He lives in Beijing.

( Image / Page 37 )

## WANG JIANWEI

Wang Jianwei (born 1958, Shuining, Sichuan Province) graduated from the Zhejiang Academy of Fine Arts in Hangzhou in 1988. Starting out as a painter, he moved on to video, film, and theater. Influenced by the work of Argentinian writer Jorge Luis Borges, Wang has described himself as a "sociological observer." Through his moving-image works, Wang documents the power struggle underlying China's changing social and political climate. Frequently inserting himself into these documentaries, he challenges the division between art and life. Recent works have included the video *Flying Bird is Motionless* (2005), which explores multiple interpretations of a given process—in this case, restaging a fight scene from Chinese popular culture—and *Cross Infection* (2007), a video of another staged event. Wang has exhibited internationally and participated in Documenta X (1997) and the First Guangzhou Triennial (2002). He lives in Beijing.

## WANG JIN

Wang Jin (born 1962, Datong, Shanxi Province) studied painting at the Zhejiang Academy of Fine Arts, where he graduated in 1987. He has produced photography, performance art, and sculpture, as well as pieces combining all three. Among his most provocative works are *Fighting the Flood*, a 1994 performance that saw the artist pouring red pigment into a canal built during the Cultural Revolution; *Knocking at the Door* (1996), in which he painted U.S. currency on bricks taken from the Forbidden City; and *The Dream of China* (1997) an antique imperial robe meticulously replicated in clear PVC plastic and fishing line. Wang's work has been shown in several international exhibitions, including *Inside Out: New Chinese Art*, Asia Society, New York (1998) and *Between Past and Future: New Photography and Video from China*, International Center of Photography and Asia Society, New York (2004). He lives in Beijing.

## WANG JINSONG

Wang Jinsong (born 1963, Heilongjiang Province) graduated from the Chinese Academy of Fine Art in 1987 with a degree in Chinese painting. He later became involved in photography, initially as a means of capturing social phenomena. This is seen in his *Standard Family* series, which documents families from different social and economic classes, and the effects of China's stringent one-child policy. Wang's recent work has included the *Midnight News* series, which depicts TV newscasts on a lone studio monitor. His art has been shown in China, Japan, Australia, Europe and the United States. Wang currently teaches at the Fine Arts Department of the Beijing Education University in Beijing.
( Image / Page 42 )

## WANG KEPING

Wang Keping (born 1949, Beijing) is a self-taught artist. In 1979, he was a founding member of "The Stars" (*Xing Xing*), one of the earliest avant-garde artist groups in contemporary China. In 1984 he moved to Paris, where he continued to create his signature smooth wood sculptures of embracing figures, abstract heads, and female figures. He has exhibited internationally, primarily in Asia and Europe. Wang lives in France.
( Image / Page 21 )

## WANG QINGSONG

Photographer Wang Qingsong (born 1966, Hubei Province) trained at the Sichuan Academy of Fine Arts in Sichuan Province. He is best known for elaborately staged scenes, which he captures in digitally composed, lushly colored photographs. Combining traditional tales, fantasy, and a touch of reality TV, these works explore the contradictions between China's ancient traditions and its contemporary consumer culture. Though the imagery occasionally echoes well-known scenes from Western art history, Wang's photo murals most closely resemble horizontal Chinese scroll paintings. The 31-foot-long *Night Revels of Lao Li*—inspired by a 10th-century scroll painting about a disillusioned government official—was included in *Between Past and Present: New Photography and Video from China*, a museum touring exhibition that premiered in New York in 2004. More recently, Wang has had solo exhibitions in Germany, Brazil, Korea, the U.K., and other countries. He lives and works in Beijing.
( Image / Page 92 )

## WU SHANZHUAN

Wu Shanzhuan (born 1960, Zhoushan, Fujian Province) works in a range of media, including painting, drawing, installation, photography, and performance. He came to prominence in the 1980s

with experimental, often satirical works that explored language and its use in propaganda. In other works he posed nude, at times with his then-wife, Inga Thorsdottir. Wu's art was included in *Inside Out: New Chinese Art* (1998), an exhibition at New York's Asia Society. He spent more than a decade in Iceland and Germany before returning to China in 2005. Wu now lives in Shanghai.

## XIAO LU

Xiao Lu (born 1962, Hangzhou) graduated from the National Academy of Fine Arts in Beijing. She rocked the Chinese art world with her infamous "gunshot" performance during the opening of the *China Avant-Garde* exhibition, held at the National Art Gallery in Beijing, February 1989. Titled Dialogue, Xiao's installation consisted of adjacent phone booths—a relatively recent addition to the Beijing streets—flanking a red telephone in front of a mirror. Inside the booths, two students, male and female, sat talking. During the *China Avant-Garde* opening, Xiao fired two shots into the mirror in her installation, committing what one writer called "symbolic suicide." This resulted in immediate closure of the exhibition, which reopened a few days later. Xiao's action is now considered one of the most significant works of performance art in contemporary Chinese art history. After a lengthy hiatus, Xiao began making art again in the early 2000s. Her work has been exhibited in China and the United States.
( Image / Page 18 )

## XING DANWEN

Conceptual photographer Xing Danwen (born 1967, Xi'an) studied at several art schools, including the Xi'an Academy of Fine Arts and the Central Academy of Fine Arts in Beijing, where she earned her B.F.A. in painting in 1992. In the late 1980s, she began working in photography, not only documenting the experimental performances in Beijing's "East Village" artists' community but becoming one of the first contemporary artists to explore the medium as an art form. From 1998 to 2001, Xing studied in New York, where she earned an M.F.A. in photography from the School of Visual Arts in 2001. In the series *disCONNEXION* (2002-03) and *DUPLICATION* (2003), Xing examines the dark side of China's leap into industrial modernity, in images ranging from mass-produced doll parts to discarded electronics products. Her ongoing *Urban Fictions* series (begun 2004) depicts maquettes of Beijing real estate developments, shot as though they were eerily sanitized, utopian versions of the real thing—including the digital insertion of perfectly-scaled photographic figures, whose activities question the rapidly disappearing line between public and private space. Xing has exhibited widely in the U.S., Canada, Europe, Asia, and Australia. She lives and works in Beijing.

## XU BING

Xu Bing (born 1955, Chongqing) grew up in Beijing, the son of a history professor and a librarian. In the late 1970s, he studied printmaking at the Central Academy of Fine Arts in Beijing. A growing taste for artistic experimentation put him at odds with the official academy. Created in the late 1980s, his highly original *Book from the Sky* at first glance resembled a book of classical literature, but was composed of meaningless characters displayed in draped swags of manuscript. In 1990, Xu moved to the U.S., where he went on to receive international acclaim for projects like *Square Word Calligraphy*, which questioned the idea that communication is possible through language. Xu's work has been shown at museums in many countries, including the U.S., Germany, Spain, Finland, Australia, Korea, Japan, Canada, and China. In 1999, he received a MacArthur Foundation "genius" award. In 2007 Xu Bing was appointed vice president of the Central Academy of Fine Arts in Beijing, and now divides his time between New York and Beijing.
( Image / Page 32, 68 )

## YAN LEI

Yan Lei (born 1965, Hebei Province) graduated from the printmaking department of the Zhejiang Academy of Fine Arts in 1991. He first became know for *Invitation Letter to Documenta Kassel* (1997), an art project produced with fellow artist Hong Hao, which tricked many Chinese artists into thinking they'd been selected for participation in Documenta, the prestigious international art event in Germany. Yan's 2006 *Color Wheel* series recalls Op Art and psychedelia of the 1960s. His recent *Sparkling* paintings (2007) pose Western icons, ranging from a Lincoln town car to artist Jeff

Koons, against graphic sunbursts, Chinese Communist propaganda-style. Yan's work has been included in several group shows, including Documenta XII (2007), *Art in Motion* at MoCA Shanghai (2006), and the Guangzhou Triennial (2003). Yan Lei lives in Beijing.

( Image / Page 96 )

## YAN PEI-MING

Yan Pei-Ming (born 1960, Shanghai) has lived in France since 1980. In 1989 he earned his degree from the École des Beaux Arts in Dijon. He is best known for large oil painting portraits of Chairman Mao, but his works also include oversized portraits of other well-known figures, such as the Pope and Bruce Lee. Yan's work is characterized by thick, sweeping strokes of paint in a monochromatic palette, frequently in what he calls the "unaesthetic" colors of black, gray, or brown. The effect is something between a representational portrait and Abstract Expressionism—as though the act of painting were a struggle between artist and subject. Yan Pei-Ming has exhibited widely in Europe, and his art has been collected by the Pompidou Center in Paris. He lives and works in Dijon.

( Image / Page 66 )

## YANG FUDONG

Film and video artist and photographer Yang Fudong (born 1971, Beijing) graduated from the China Academy of Fine Arts in Hangzhou in 1995. In videos and dreamlike, open-ended films like *No Snow on the Broken Bridge* (2006) and *Seven Intellectuals in the Bamboo Forest, Part I* (2003), Yang explores his generation's

attempts to define themselves amid the growing affluence and spiritual rootlessness of contemporary China. He was a finalist for the Hugo Boss Award in 2004, and has participated in many international exhibitions, including Documenta XI (2000), the 50th Venice Biennale (2003), the 5th Shanghai Biennale (2004), and the First Moscow Biennale of Contemporary Art (2005). He lives in Shanghai.

( Image / Page 41 )

## YANG JIECHANG

Yang Jiechang (born 1956, Guangdong Province) graduated from the Guangzhou Academy of Fine Arts in 1982. Traditional calligraphy and Chinese painting techniques are a visible influence in his installations, sculptures, collages, and performance art. Yang first gained international recognition with his large ink paintings, featured in *Les Magiciens de la Terre* at the Pompidou Center in Paris in 1989. More recently, his multimedia installation and performance work, *Storyteller's RAP* (2003) was featured at the 5th Shenzhen International Sculpture Biennale. His installation for the 2006 Tate Liverpool Biennale, *I Can Cram the Desolate Place in Liverpool if You Give Me 33 Years*, brought the ancient technique of acupuncture to bear on the city itself. Yang's work has been exhibited in China, Germany, France, Hong Kong, Spain, and other countries. He currently divides his time between Paris and Heidelberg, Germany.

## YANG SHAOBIN

Yang Shaobin (born 1963, Handan, Hebei Province) graduated from

the Hebei Light Industry Institute in 1983. In the early 1990s he was among the avant-garde artists who established the "East Village" community on the outskirts of Beijing. From realist paintings of soldiers in uniform and men in combat, his work evolved into semi-abstract figures with deformed faces and struggling bodies, often painted in red. Other recent work includes large sculptures of similarly mangled and distorted figures. Yang has had solo shows in Hong Kong, Berlin, London, and Paris, and has participated in many group exhibitions worldwide. He lives in Beijing.

( Image / Page 36 )

## YIN XIUZHEN

Yin Xiuzhen (born 1963, Beijing) trained in painting at the Fine Arts Department of Capital Normal University, graduating in 1989. An installation artist since the early 1990s, she has lived and worked in Beijing almost continuously since that time. Because of this, Yin's art is a tangible documentation of the rapid urbanization and modernization that has taken place in the city. Many of her large-scale pieces are made with materials donated from neighborhood people, such as used fabrics, shoes, and clothing. These "recycled" works address issues of the changing urban landscape and the waning of communal values. In her *Collective Unconscious* series, for instance, mini-vans are lengthened into something resembling vehicular caterpillars, adorned with colorful donated clothing and fabrics. Yin has had solo exhibitions in New York (2006), Germany

(2004), Australia (2002), and China (1996), and has taken part in many international group exhibitions.

## YUE MINJUN

Yue Minjun (born 1962, Daqing, Heilongjiang Province) studied oil painting at Hebei Normal University. He is best known for colorful paintings and sculptures showing the artist himself—often in clone-like multiples—with a broad, toothy grin. He is one of the key figures in the Cynical Realism movement, which emerged in response to the Tiananmen Square incident of June 1989. In the period of government repression that followed, Yue's playful, smiling figures offered an ironic commentary on the concept of personal freedom and happiness in modern Chinese society. Yue is widely considered one of the most important contemporary Chinese artists. His work has been exhibited in museums and galleries in the United States, Europe, Asia, and Australia, and his oil paintings have set records at auction. Yue's first U.S. retrospective was presented at the Queens Museum of Art in New York in 2007. He lives and works in Beijing.

( Image / Pages 30, 94 )

## ZENG FANZHI

Zeng Fanzhi (born 1964, Wuhan, Hubei Province) studied painting at the Hubei Academy of Fine Arts. Working in a vividly expressionistic style, he depicts China's new business class, men whose wide-eyed faces meld into white masks that freeze their expressions in stiff smiles. Other subjects have included slaughterhouses and hospitals populated by overbearing doctors and anguished patients. Zeng Fanzhi has had solo shows in France, Singapore, Seoul, Shanghai and Shenzhen, and participated in the First Guangzhou Triennial (2002). He lives in Beijing.

( Image / Page 12 )

## ZHAN WANG

Sculptor Zhan Wang (born 1962, Beijing) studied at both the Beijing Industrial Arts College and the Central Academy of Fine Arts in Beijing. He is best known for his modern interpretations of ancient Chinese "scholar's rocks," which were traditionally chosen from nature for the grace and richness of their forms, contours, and surface textures. Working primarily in stainless steel, Zhan crafts sleek, gleaming updates on these traditional objects, evoking the elegance and immutability of their ancient inspirations. Zhan has participated in numerous exhibitions, such as the *First Academic Exhibition of Chinese Contemporary Artists*, Hong Kong (1996), *A Revelation of 20 Years of Contemporary Chinese Art*, Beijing (1998), and *The New Chinese Landscape*, Arthur M. Sackler Museum, Harvard, Cambridge MA (2006). He lives and works in Beijing.

( Image / Page 79 )

## ZHANG DALI

Zhang Dali (born 1963, Harbin) graduated from the Central Academy of Fine Arts in Beijing in 1987. In the late 1980s, Zhang moved to Europe, where he first encountered urban graffiti. Attracted by its speed and simplicity and the opportunity for making art outside the studio, he began doing graffiti in Beijing when he returned there in the mid-1990s. He is best known for *Dialogue*, an ongoing work of more than 2,000 pieces of graffiti—primarily heads in profile, his signature symbol—painted on buildings slated for demolition throughout Beijing. Many of the heads were later chiseled out to reveal unsettling glimpses of Beijing's rush toward modernization. More recent work has focused on the growing phenomenon of China's migrant workers: impoverished rural dwellers forced to seek employment in already overcrowded urban centers. Zhang has depicted this new underclass in individual portraits (painted in a repeating pattern of "AK-47," the artist's early graffiti name) and in resin casts of workers' heads and bodies. He has also returned to his graffiti head symbol and the AK-47 "tag," rendering them in bright neon sculptures. Zhang lives and works in Beijing.

( Image / Page 62 )

## ZHANG HUAN

Zhang Huan (born 1965, Anyang, Henan Province) graduated from the Central Academy of Fine Arts in Beijing in 1993. During the mid-1990s he and other avant-garde artists established the "East Village" artists' enclave on the outskirts of Beijing. It was there that Zhang first attracted attention for provocative works such as *12 Square Meters*, a performance in which the artist, covered in honey, sat naked in a public toilet for almost an hour as flies covered his unflinching body. In addition to performance art, Zhang has worked in a variety of

media, including painting, prints, photography, installation art, and large-scale sculpture. His work is held in several collections, including New York's Museum of Modern Art and Guggenheim Museum, the Museum of Contemporary Art, Barcelona, the National Gallery of Australia, and the Israel Museum in Jerusalem. Solo exhibitions in 2007-2008 were presented in New York, London, Berlin, Madrid, Shanghai and Vancouver. Zhang Huan now lives in Shanghai and New York.
( Image / Pages 6, 56 )

## ZHANG PEILI

Zhang Peili (born 1957, Hangzhou) graduated from the Zhejiang Academy of Fine Arts with a degree in oil painting in 1984. He was a founding member of two different non-official art groups of the early 1980s: the "New Space" group (1985) and the "Pool Society" (1986). Though first acclaimed as a painter, Zhang is now known as a pioneer of video art in China, and his video style is considered an influence on the Cynical Realism movement of the early 1990s. Zhang's work has been shown internationally since 1993, and is in the collections of New York's Museum of Modern Art, the Pompidou Center in Paris, the Fukuoka Asian Art Museum in Japan, the Queensland Art Gallery in Australia, and other institutions. He is chair of the New Media Department at the China Academy of Art in Hangzhou.
( Image / Page 13 )

## ZHANG XIAOGANG

Zhang Xiaogang (born 1958, Kunming, Yunnan Province) graduated from the Sichuan Academy of Fine Arts in 1982. In the 1980s, he emerged as a leading painter of the Sichuan School, whose art probed the psychological impact of China's recent political history. Inspired by old family photographs, his *Bloodline* series explores themes of personal identity in the context of family, politics, and modern China's rapidly dissolving tradition of collectivism. Mirroring the language of the studio photograph—formally posed and rendered in the soft grays of a black-and-white photo—these dreamlike figures, jolted by unexpected blasts of color, hint at the turbulence that lies beneath their stoic exteriors. Zhang's work has been presented internationally, with solo shows in Finland, Hong Kong, New York, Paris, and Taiwan. He participated in 46th Venice Biennale (1995), the Shanghai Biennale (2004), and the First Guangzhou Triennial (2002). He lives in Beijing.
( Image / Page 31 )

## ZHOU CHUNYA

Zhou Chunya (born 1955, Chongqing) studied painting at the Sichuan Academy of Fine Art and in the Experimental Art Department of the Kassel Academy of Fine Art in Germany. He is best known for his depictions—on canvas and more recently in bronze and painted metal sculpture—of a beloved pet German shepherd. Sometimes depicted with other dogs but usually alone, the comical animal is invariably portrayed as bright green with a deep-pink tongue. More recently, Zhou has done a series of works depicting sexual encounters between couples in natural settings. Zhou has exhibited widely in China as well as in the U.S., Holland, France, Ireland, Poland, Norway, England and Italy. He lives in Chengdu.
( Image / Page 39 )

## ZHU MING

Zhu Ming (born 1972, Hunan Province) was one of the artists who participated in *To Add One Meter to an Anonymous Mountain* (1995), a milestone performance piece in contemporary Chinese art. He later became known for his *Bubble* series (begun in 1997), a work that took the naked artist floating out to sea inside a soft plastic bubble, in locations ranging from Hong Kong to Sydney and Miami. In a more recent series, *Luminescent Man*, Zhu is also shown naked inside a plastic sphere, this time coated with fluorescent paint and performing in a darkened space. Zhu's work has been included in *Fuck Off*, the Shanghai Biennale satellite exhibit organized in part by Ai Weiwei (2000) and *Between Past and Future: New Photography and Video from China* (2004), which debuted in New York. Zhu Ming lives in Beijing.

## Further Reading

Andrews, J. F. *Painters and Politics in the People's Republic of China 1949-1979*. Berkeley: University of California Press, 1994.

Barmé, G. "Exploit, Export, Expropriate: Artful marketing from China." *Third Text*, vol. 25 (Winter), 1993-94: 67-76.

Chang, T. Z. *The Stars: Ten years* [exhibition catalogue]. Hong Kong: Hanart 2 Gallery, 1989.

Chiu, M. *Breakout: Chinese Art Outside China*. Milan: Charta, 2007.

Clark J. "Official reactions to modern art in China since the Beijing massacre." *Pacific Affairs*, vol. 65, no. 3, 1992: 344-358.

Doran, V., ed. *China's New Art, Post-1989* [exhibition catalogue]. Hong Kong: Hanart T Z Gallery, 1993.

Driessen, C., and H. van Mierlo, eds. *Another Long March: Chinese Conceptual and Installation Art in the Nineties* [exhibition catalogue]. Breda, the Netherlands: Fundament Foundation, 1997.

Erickson, B. *On the Edge: Contemporary Chinese Artists Encounter the West* [exhibition catalogue]. Stanford, CA: Iris and Gerald B. Cantor Center for Visual Arts, 2005.

Fei, D., ed. *'85 New Wave: The Birth of Chinese Contemporary Art*. Beijing: Ullens Center for Contemporary Art, 2007.

Fibisher, B. and Frehner, M. eds. *Mahjong—Contemporary Chinese Art from the Sigg Collection*. Ostfildern-Ruit, Germany: Hatje Cantz, 2005.

Gao, M., ed. *Inside Out: New Chinese Art* [exhibition catalogue]. New York: Asia Society Galleries, 1998.

Gao, M. *The Wall: Reshaping Contemporary Chinese Art* [exhibition catalogue]. Buffalo: Albright-Knox Art Gallery, 2005.

Hou, H. "Entropy: Chinese artists, western art institutions: A new internationalism." *Global visions: Towards a New Internationalism in the Visual Arts*, J. Fisher, ed., 79-88. London: Kala Press, 1994.

Noth, J., W. Pöhlmann, and K. Reschke, eds. *China Avant-Garde: Countercurrents in Art and Culture* [exhibition catalogue]. Hong Kong: Oxford University Press, 1993.

Smith, K. *Nine Lives: The Birth of Avant-Garde Art in New China*. Zurich: Scalo, 2006.

Strassberg, R., ed. *"I don't want to play cards with Cézanne" and Other Works: Selections from the Chinese "New wave" and "Avant-garde" Art of the Eighties* [exhibition catalogue]. Pasadena, CA: Pacific Asia Museum, 1991.

Sullivan, M. *Art and Artists of Twentieth-century China*. Berkeley: University of California Press, 1996.

Van Dijk, H. and I. Lindemann, eds. *China: Aktuelles aus 15 Ateliers, Performances, Installationen* [exhibition catalogues]. Beijing: New Amsterdam Art Consultancy, 1996.

Wu, H. *Transience: Chinese Experimental Art at the End of the Twentieth Century* [exhibition catalogue]. Chicago: The David and Alfred Smart Museum of Art, The University of Chicago, 1999.

_____. *Exhibiting Experimental Art in China* [exhibition catalogue]. Chicago: The David and Alfred Smart Museum of Art, The University of Chicago, 2000.

Dr. Melissa Chiu is Museum Director and Vice President, Global Art Programs, Asia Society in New York, where she has worked since 2001. Previously, she was Founding Director of the Asia-Australia Arts Centre in Sydney, Australia (1996-2001). As a leading authority on Asian contemporary art, she has guided a number of major initiatives at the Asia Society Museum, including the launch of a contemporary art collection to complement the museum's outstanding Rockefeller Collection of traditional Asian art.

Chiu is a visiting professor at the CUNY Graduate School, and has lectured at numerous American universities, including Harvard and Columbia. She was a Getty Research Fellow (2003-2004) and is a member of the academic advisory board, Asia Art Archives, Hong Kong; advisory board, *Yishu: Journal of Contemporary Chinese Art*, Vancouver; an advisor to *Art 21*, a television series on contemporary art broadcast on PBS; board member, Vietnam Foundation for the Arts; and a founding member of the Asian Contemporary Art Consortium in New York.

Dr. Chiu has curated nearly thirty exhibitions of international art. She has served as an editor for Asian contemporary art for *The Grove Dictionary of Art* (Oxford University Press, London and New York), and is the author and editor of several books, monographs, and anthologies, among them a book on the Chinese contemporary artist Zhang Huan. Her most recent work, *Breakout: Chinese Art Outside China* (Charta, 2007), focuses on the international Chinese art diaspora.

**Chinese Contemporary Art: 7 Things You Should Know**
By Melissa Chiu

Published by AW Asia

AW Asia
545 West 25th Street
New York, NY 10001
212.242.3700 t
212.242.3557 f
info@awasiany.com
www.awasiany.com

Projects · Exhibitions · Publishing

Distributed in North America by AW Asia

AW Asia is a private office and exhibition space dedicated to the promotion of Chinese contemporary art. AW Asia's initiatives include exhibitions, curatorial projects, publications, and educational programming. For more information, please visit www.awasiany.com.

Design: RedBox Studio   www.redboxstudio.cn
Editor: Susan Delson
Research Assistants: Taliesin Thomas, Austin M. Powers

Printed in China
ISBN: 978-0-9785764-3-1